Van Gogh

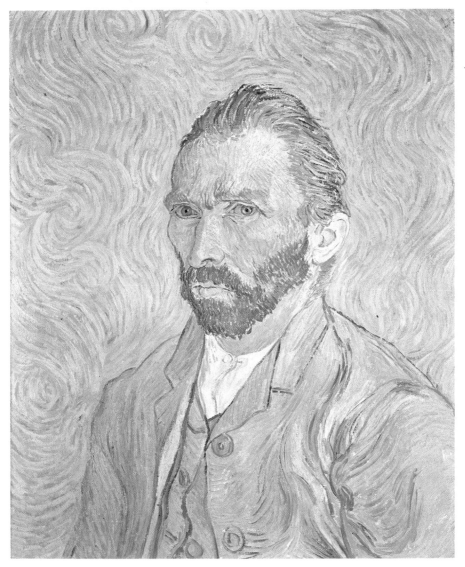

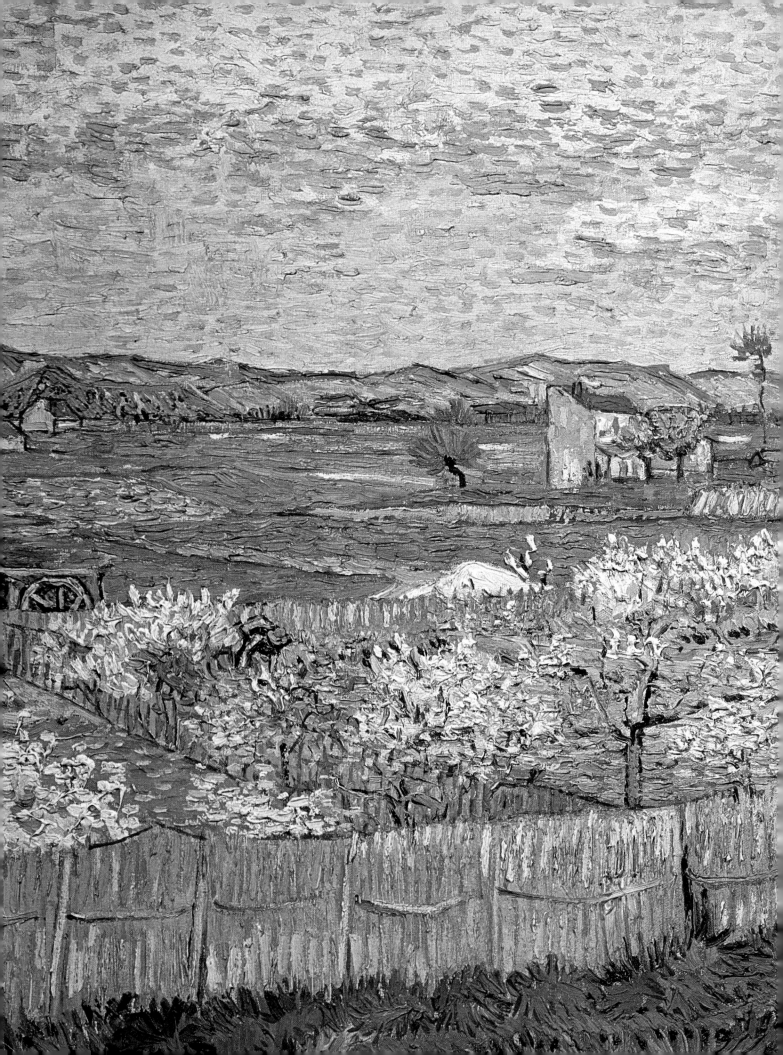

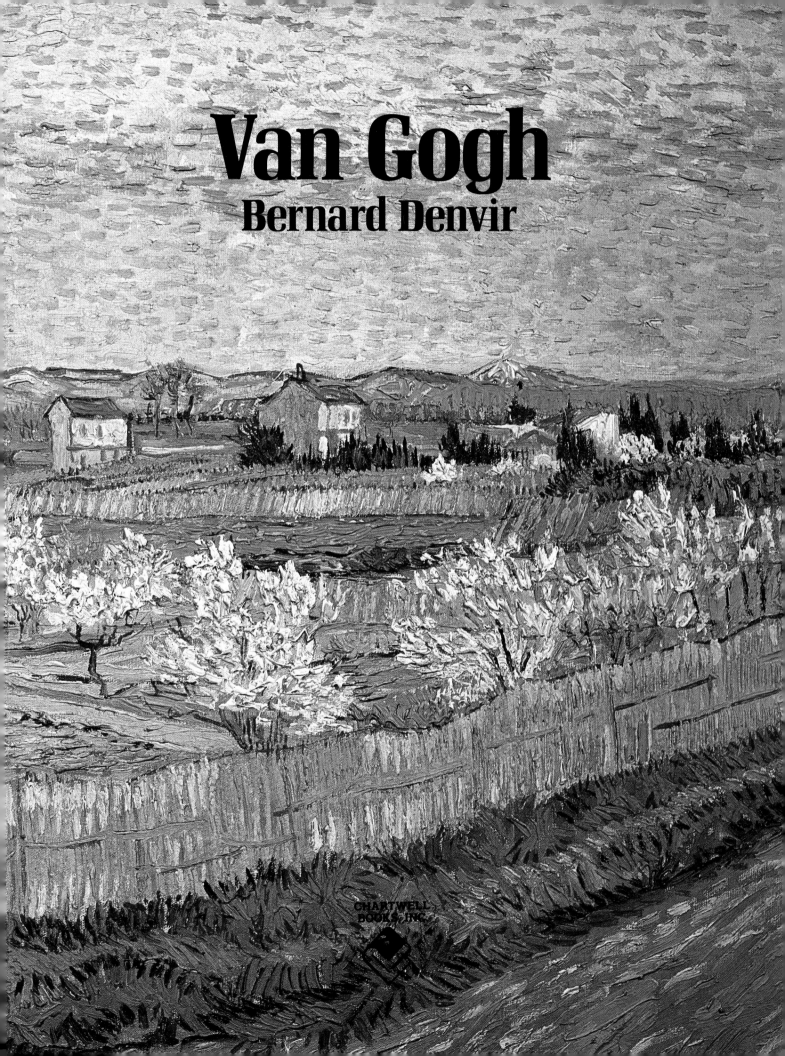

Van Gogh

Bernard Denvir

CHARTWELL
BOOKS, INC.

HALF-TITLE PAGE *Self-portrait* (September 1889),
Paris: Louvre

TITLE SPREAD *Peach-trees in blossom in La Crau*
(April 1889), London: Courtauld Institute Galleries

THIS SPREAD *Reaper in a wheat-field* (July 1889),
Amsterdam: Rijksmuseum (Vincent van Gogh Foundation)

First published in Great Britain in 1981 by
Octopus Books Limited

This 1990 edition
Published by
CHARTWELL BOOKS, INC.
A Division of BOOK SALES, INC.
110 Enterprise Avenue
Secaucus, New Jersey 07094

ISBN 1-55521-601-3

Printed in Hong Kong

Contents

Van Gogh's Place in Art

On the evening of 27 July 1890, in a field near the village of Auvers-sur-Oise, north-west of Paris, Vincent van Gogh put a pistol to his chest and shot himself; the bullet lodged near his spine and he died two days later, at the age of 37. By almost every criterion his life had been a failure: he had for years been dogged by physical and mental illness; he had seemed incapable of sustaining personal relationships for long; and his paintings had achieved neither critical nor commercial success (even Paul Cézanne, one of the artists Van Gogh most admired, had described them as the works of a madman).

Since his death, however, and particularly during the last 40 years, Van Gogh has become one of the great hero-figures of 20th-century culture. His life has been the subject-matter of plays, novels, and films; more books have been written about him than about any other artist of our time. His paintings, which adorn the walls of most of the great museums and art galleries of the western world, fetch fabulous prices on the not very rare occasions that they turn up in the salerooms, and they have received that definitive accolade of success, the attention of many versatile and skilful forgers. To millions of people Van Gogh has become the epitome of the romantic artist – despised and rejected in his own lifetime, struggling against adversity, and ultimately achieving posthumous fame. He has been transformed, as it were, into the St Francis of a secular religion.

With no other artist is it more difficult to disentangle truth from fiction, fact from legend, in spite of his voluminous correspondence. And this is all the more regrettable in that he was one of the key figures in the art of our time, a painter whose influence is still significant in the late 20th century, and a pioneer in the abstract use of form and colour for their symbolic and expressive values.

One thing is certain. He was no divinely possessed idiot, but a shrewdly perceptive observer of his own life and actions, able even to annotate his mental disorders. His letters, written to his friends and relatives – mainly to his younger brother, Theo – amount in themselves to a remarkable autobiographical achievement and throw light on a multitude of artistic as well as personal problems, forming a superb commentary on his own work and creative ideals. He was widely read and was especially devoted to the works of George Eliot, Dickens, Christina Rossetti, Michelet, Balzac, Zola, Flaubert, and Carlyle. In addition to his native language, he could speak French and English fluently. His knowledge of the old masters and of contemporary painting was extensive. Nor was he without economic ambitions. His letters abound in projects for displaying and selling his works, although none of these came to fruition.

His endearing, if unfocussed, concern for his fellow-human beings, and his sympathy for the oppressed, co-existed with a notorious inability to get on for long with individual people. Both these aspects of his character were shown in his relationship with the prostitute Sien, to whom he gave shelter in 1882 but callously abandoned a year later. Brought up in the closely knit circle of family life within a Dutch parsonage, he was treated by his parents with a tolerance and understanding which he only intermittently reciprocated. His closest relationship was with his brother Theo, who helped Vincent in every possible way, providing for him financially, often at great strain to himself, putting up with his tantrums and reproaches, and providing such constant and loving support that

Self-portrait with pipe
Paris, early 1886
Oil on canvas
27 × 19 cm (10⅝ × 7½ in)
Amsterdam: Rijksmuseum (Vincent van Gogh Foundation)

Van Gogh painted no fewer than 35 self-portraits in oils during the four years from his arrival in Paris in February 1886 to his death in July 1890. No doubt one reason for this was that he seldom had any money for models. But more important was his desire to know himself, and the self-portrait can be seen as reflections of a continuous process of self-interrogation, of a desire to project an image of both his outer form and his personality. In this, the earliest of these self-portraits (painted in 1886 and reworked in 1887), the first impact of his discovery of Impressionism is clearly discernible, but the general approach is still a traditionalist one. The general impression is benign and relaxed, with no hint of the anxieties which are reflected even in others painted only a few months later. It is interesting to note throughout the whole series of self-portraits the extent to which Van Gogh concentrated on the expression of the eyes, making them reflect very clearly his state of mind.

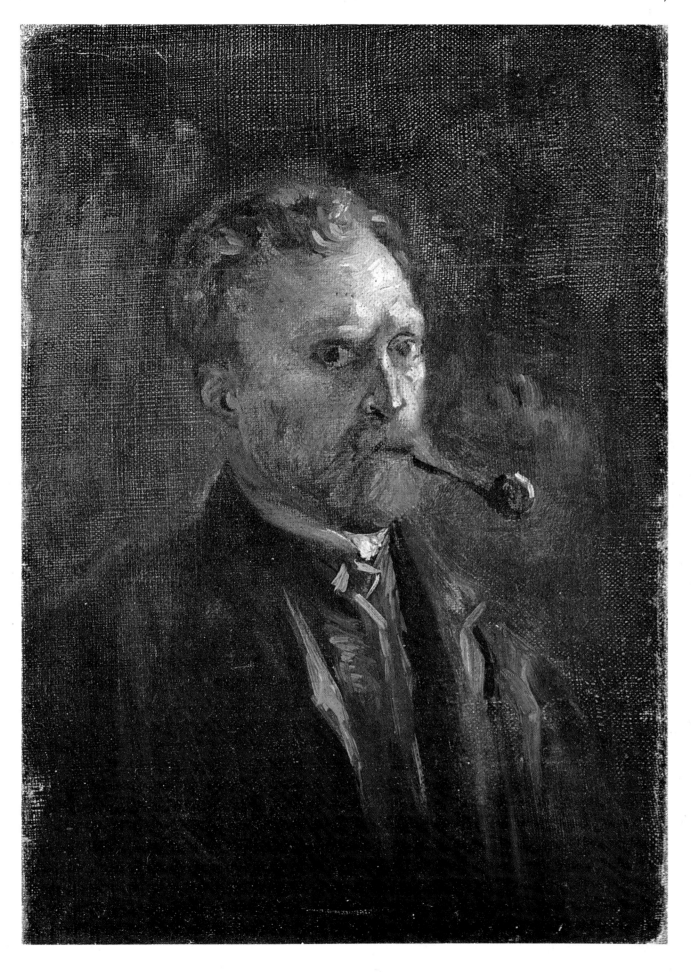

without it Van Gogh would either have perished earlier or given up his ambition to become an artist.

None of the many self-portraits which he painted give a clear idea of the impression he made on others; they are all exercises in self-exploration, in which the artist interrogates his own face as a window onto his soul. But there is a description by the English artist A. S. Hartrick, who knew him in Paris, which has the ring of truth about it: 'Van Gogh was a rather weedy little man, with pinched features, red hair and beard, and a light blue eye. He had an extraordinary way of pouring out sentences, if he got started, in Dutch, English, and French, then glancing back at you over his shoulder, and hissing through his teeth. To tell you the truth, I think the French were civil to him largely because his brother Theodore was employed by Goupil and Company, and so bought their pictures.'

Van Gogh seems to have presented a deeply ambiguous face to the world – something that Theo once described in a letter to their youngest sister Wilhelmien: 'It seems as if he were two persons; one marvellously gifted, tender, and refined; the other egoistic and hard-hearted. They present themselves in turns, so that one hears him talk, first in one way, then in another, and always with arguments on both sides. It is a pity that he is his own worst enemy, for he makes life hard, not only for others but for himself.'

Whatever the shifts and contradictions in his personal relationships, whatever the eccentricities of his behaviour, one consistent element in Van Gogh's life, from the age of 26 onwards, was his devotion to art, his relentless ambition to become a painter. Part of his output must have been lost or destroyed, but that which survives consists of more than 800 oil paintings and an even larger number of drawings and water-colours. Most of these were executed within the space of eight years – 1882–90. Remarkable as it is in sheer quantity, this body of work is even more striking for its revelation of technical and artistic development. Although he received some training from his cousin Anton Mauve, and briefly attended art classes at Antwerp, Brussels, and Paris, Van Gogh was essentially self-taught. His early works, influenced by Millet and dealing mainly with peasant life, are dark in tonality, provincial in feeling, and show little awareness of the great changes which had taken place in European painting since the first Impressionist group exhibition of 1874. But what they lacked in technical sophistication they compensated for in feeling, and in a certain almost brutal strength derived, in part at least, from the terrific struggle against artistic inexperience which had gone into their making.

Sheer, dogged persistence taught him many things, but it was not until he arrived in Paris in the winter of 1886 that the full impact of what had been happening in the art world really burst on him. The Impressionists had discovered a new universe of light and colour, expressing through complex technical skills their immediate, instantaneous perceptions of the world around them. Quickly Van Gogh absorbed all this, talking endlessly (and listening occasionally) to the artists he got to know, among them Toulouse-Lautrec, Pissarro, Degas, and Gauguin. Using a brighter palette and broken brush-strokes, he painted views of Paris and its suburbs, still-lifes, and self-portraits. But having absorbed the lessons of Impressionism, he soon became aware that other things were going on, too – reactions against the recent innovations. He became friendly with Paul Signac, who with Georges Seurat was endeavouring to create a more disciplined form of painting, based on theories about colour and the way it affects the eye. This 'scientific' approach, known as Divisionism or Pointillism, influenced Van Gogh for a while, and confirmed his devotion to the use of spots of different colours to add scintillating effects.

But more influential for his own pictorial language was a new attitude to colour – implicit in the work of Henri de Toulouse-Lautrec and explicit in the work of the exuberant, domineering Paul Gauguin. The stormy, ambivalent relationship between Gauguin and Van Gogh, culminating in the famous episode of the cut ear, has become one of the most famous in

Self-portrait in straw hat
Paris, summer 1887
Oil on pasteboard
19×14 cm ($7\frac{1}{2} \times 5\frac{1}{2}$ in)
Amsterdam: Rijksmuseum (Vincent van Gogh Foundation)

Staying in Paris with his brother Theo, Van Gogh seemed to improve in health and become more relaxed in his behaviour. Theo wrote to their parents, 'You would not recognize Vincent, he has changed so much, and it strikes other people even more than it does me. He makes great progress, and has begun to have some success. He is in much better spirits than before, and many people here like him. . . . If we can continue to live together like this, I think the most difficult period is past, and he will find his way.' There seems to be some justification for Theo's optimism in this self-portrait, one of many he painted in the second half of 1887. Van Gogh is smartly dressed, in a velvet jacket and bow tie, looking very much the moderately successful artist. It is only in the eyes that one detects strain and apprehension.

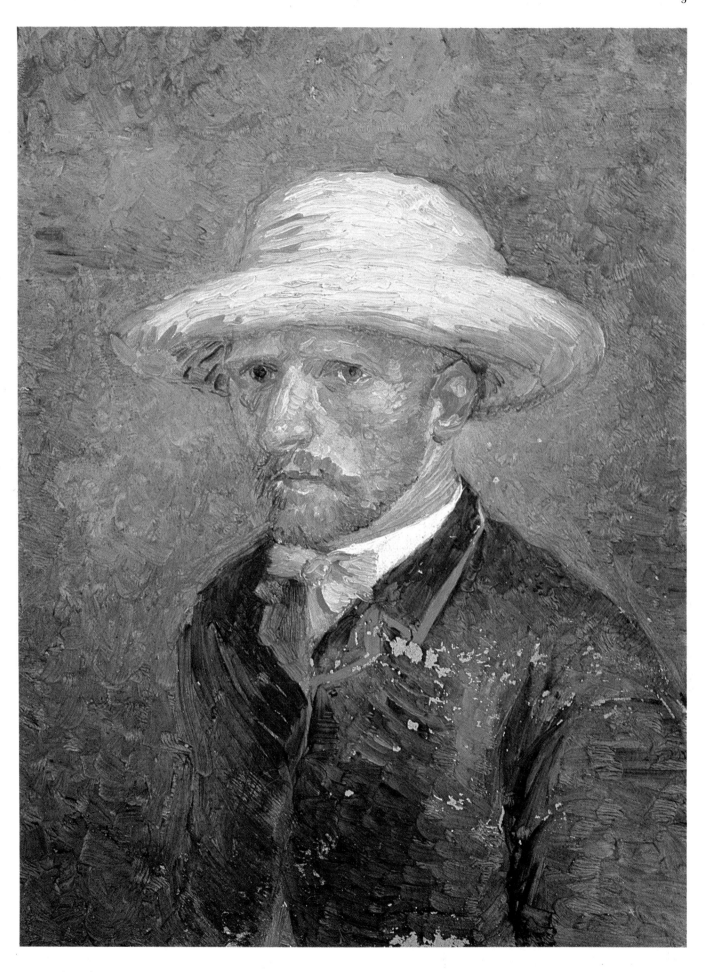

the history of art. There were personal undercurrents involved. Face to face with Gauguin's swaggering masculinity, Van Gogh felt weak and impotent, and this was aggravated by the fact that although he greatly admired the simplified, solid, well-defined forms and clear, flat colours of the Frenchman's paintings, he resented the master-pupil relationship which Gauguin was trying to establish. Some time afterwards Gauguin described his version of the relationship to the writer Charles Morice: 'When I first came into contact with Vincent he was up to his neck in the Neo-Impressionist [Divisionist] school, which made him unhappy, not because that school is bad but because it did not suit his nature, which lacked patience and understanding. I took it upon myself to enlighten him, which was easy, for the soil was rich and fruitful. From that day on he made astonishing progress; he seemed to glimpse all that was in him.'

This 'glimpse' in actuality had first been made early in 1888, when Van Gogh left Paris for Arles in Provence. Like many northerners, he was seduced absolutely by the warmth, the colour, the clear bright sea and sky of the Mediterranean. Gone was his Flemish concern with peasant life, gone his preoccupation with technicalities of light and structure. Provence revealed to him a world of bright colour accentuated by the strong sunshine – a world of blossoming trees, red earth, strong blue shadows, picturesque people. 'I am convinced,' he wrote to Theo, 'that a long sojourn here is just what I need to enable me to affirm my personality. Nature here is so *extraordinarily* beautiful. Everywhere, and over all, the vault of the sky is a marvellous blue, and the sun sheds a radiance of pale sulphur; it is as soft and blue as the combination of celestial blues and yellows in Vermeer's paintings. I cannot paint it as beautifully as that, but it absorbs me so much that I let myself go without thinking of any rules.'

Provence brought him full self-realisation as an artist. The works he painted there have become amongst the most celebrated in the history of art – fierce hymns to the beauty of the world, painted in colours of a violence and purity which had never before been seen on canvas. But Provence exacted a terrible price. Under the heat of that southern sun, inflamed by excessive drinking of absinthe, and weakened by under-nourishment, he began to lose control of his sanity. The personality stresses which had been apparent in the past became more noticeable, and the schizophrenia which Theo had already noted became more violent. His behaviour was increasingly erratic; complete breakdowns occurred with delirium and hallucinations; the ecstasy of his paintings sometimes came close to frenzy. When the attacks became more frequent in the last few days of 1888 he was interned at the Arles hospital; and then in May 1889, at his own request, he was moved to the asylum at nearby Saint-Rémy-de-Provence, where he stayed for a year, working feverishly in the intervals between attacks, and conscious all the time of what was happening to him.

In May 1890, after a short visit to Theo in Paris, Van Gogh went to Auvers-sur-Oise, and it was there, far from the domestic warmth of his native Holland, far from the sunny splendours of Provence, that in a state of apparent lucidity he met his desperate, lonely end.

Van Gogh's contribution to western art is of incalculable importance. More than any artist before him he made colour into a language which could describe feeling as well as define form, which could arouse emotion without being dependent on the description of appearances. Within his own art he drew together all the strains of the Romantic legacy, and passed them on in an enhanced form to the 20th century. Without his example and discoveries, several of the more significant movements in modern painting – notably the Fauves in France, the Expressionists in Germany, and the Abstract Expressionists in New York – could not have evolved as they did. His influence in the late 20th century is as important as it has ever been. But, more important than this, the radiance of his works, their sense of joy and exuberance, born from intense personal anguish and private suffering, have brought happiness to countless millions of people all over the world.

Self-portrait in front of an easel
Paris, early 1888
Oil on canvas
65 × 50.5 cm (25½ × 20 in)
Amsterdam: Rijksmuseum (Vincent van Gogh Foundation)

This is the culmination of the series of self-portraits which Van Gogh had begun in the later months of 1887 and which he saw as exercises in Impressionism. Some months later he wrote about it to his sister Wilhelmien: 'Here I give a conception of mine, which is the result of a portrait I painted in the mirror, and which is now in Theo's possession. A pinkish grey face with green eyes, ash-coloured hair, wrinkles on the forehead, stiff, wooden, a very red beard, neglected and mournful, but the lips are full; a blue peasant's blouse of coarse linen; and a palette with citron-yellow, vermilion, malachite green, cobalt blue – in short, all the colours on the canvas except the orange beard, but only pure colours. The figure is against a greyish-white wall. You will say that this is rather like a death's head; well, yes, that's the sort of face it is, and it isn't easy to paint oneself, at any rate it's quite different from a photograph. And this, in my opinion, is the great advantage of Impressionism.' Both in the range of pure colours and in the distinct pattern of thick brush strokes this reveals the impact which the painters of Paris had exerted on him.

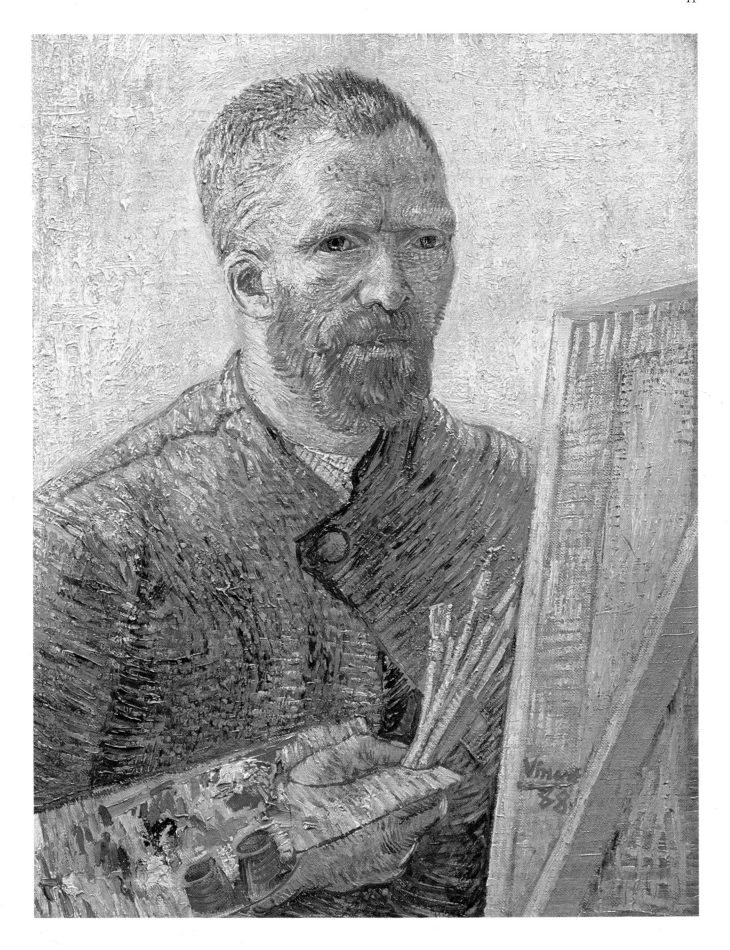

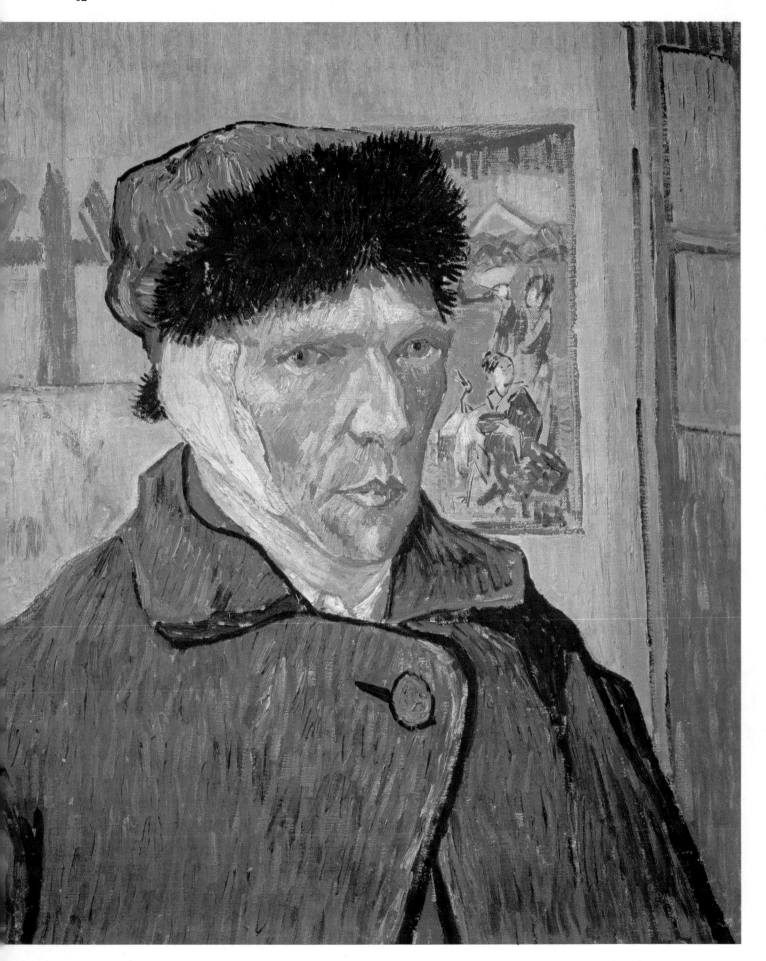

Self-portrait with bandaged ear
Arles, January 1889
Oil on canvas
60 × 49 cm (23½ × 19¼ in)
London: Courtauld Institute
Galleries

Probably the most notorious incident
in Van Gogh's life, the mutilation of
his ear on 23 December 1888 is
bedevilled by conflicting accounts
and explanations. Whatever its
deeper motivation, the act was
probably committed in a mood of
frenzy triggered by alcohol.
Afterwards he spent two weeks in
hospital, where his condition was
described as 'acute mental
derangement accompanied by
general delirium'. Immediately on his
discharge he painted this portrait for
Theo, presumably to reassure him.
He looks haggard and depressed,
although the print on the wall, by
the Japanese artist Satō Torakiyo,
adds a note of brightness and even
hope. (The damaged ear, of course,
was the *left* one: Van Gogh painted
from his reflection in a mirror.)

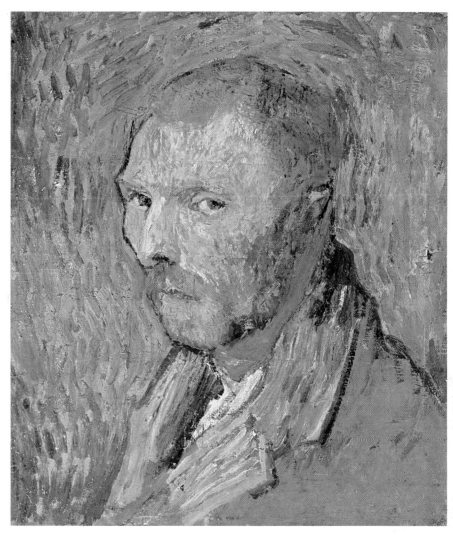

HOT ROCKS

Self-portrait
Saint-Rémy, September 1889
Oil on canvas
51 × 45 cm (20 × 17¾ in)
Oslo: Nasjonal Galleriet

Van Gogh's most severe and
sustained attack of insanity at the
asylum in Saint-Rémy lasted from
8 July to the middle of August 1889,
and he took a considerable time to
recover from it. 'I am struggling with
all my energy to master my work',
he wrote to his brother Theo,
'thinking that if I succeed that will
be the best lightning-conductor for
my illness.' He started on a series of
self-portraits, partly to reassure his
mother (to whom he sent one) and
partly to enable him to assess his
own condition. This one is perhaps
the most poignant of the series: he
eyes the viewer (and himself) with a
combination of sad but watchful
intensity and depressed resignation.
He observed to his mother: 'I keep
looking more or less like a peasant
of Zundert'.

The Fruits of Adversity

Few great artists have made so many false starts as Vincent van Gogh; few have had so little professional training. He was born on 30 March 1853, the son of the pastor of Groot-Zundert, south of Breda, near the Netherlands' frontier with Belgium. At the age of 16 he became a junior assistant in the art firm of Goupil in The Hague, and after four years there was transferred to the London branch of the firm in Southampton Street off the Strand. The two years he spent in England were carefree and illuminating, stimulating his interest in art and his feeling for the quality of contemporary life, as expressed in the remarkable illustrations which well-known British painters drew for magazines such as *The Graphic.*

In May 1875 he was moved to the main Paris office of Goupil, and a year later was dismissed, largely because of his opinion that picture-dealing was 'a form of organized fraud'. By now his main passion was religion, and within a few weeks of leaving Goupil's he had returned to England where, after a short spell of teaching at a prep-school at Ramsgate, he became a lay preacher and church social worker at Isleworth, Richmond, and Turnham Green. At Christmas 1876 he went home and, after working in a bookshop at Dordrecht for four months, he began to study for the entrance exam for the theology faculty of the university of Amsterdam. This project was soon abandoned and he joined an evangelical training college in Brussels. He failed to qualify, however, and decided to go to work amongst the miners of the Borinage, a district in the south of Belgium near Mons. There he threw himself into evangelical and social work with such self-denying fervour that he alarmed his religious superiors, and in July 1879 he was dismissed 'for irregular behaviour'.

The next 12 months were a period of great hardship, in which he made the momentous decision to become an artist. He began to draw seriously, making copies of prints and engravings by artists such as Millet and doing the drawing-book exercises published by Goupil. 'I said to myself,' he wrote to Theo, who was now supporting him, 'I will take up my pencil, which I have forsaken in my discouragement, and I will go on with my drawing. From that moment everything has seemed transformed for me.'

With the help of Theo, he spent several months in Brussels taking lessons in anatomy and perspective, and then returned home for a seven month spell, producing many drawings in the style of Millet, falling in love with his cousin Kee, and eventually at Christmas in 1881 had a violent row with his father, and moved to The Hague, where he studied painting for about a year under his cousin, the highly successful Anton Mauve (1838–88). In March, impelled by that curious mixture of masochism, humanitarianism, and idealism which seems so characteristic of him, he set up home with 'Sien' (Clasina Maria Hoornick), a pock-marked, surly prostitute, and her child. By now he saw himself as 'an illustrator of the people', and had produced some 25 surviving oil paintings, and 300 drawings and watercolours. But, by September 1883, having quarrelled with Mauve and alienated most members of the artistic community of The Hague, he left for Drenthe, a remote fishing area, and at Christmas returned to the family home, which was now in Nuenen. There he stayed for nearly two years, nursing his mother and being present at the death of his father in March 1885. In November of that year he arrived in Antwerp, where he became passionately interested in Japanese prints. It was here that he apparently contracted venereal disease. At last, on 27 February, now both ill and severely undernourished, he left to live with Theo in Paris.

Old man with top hat
December 1882
Pencil, black lithographic chalk, pen and brown ink on thick water-colour paper
60.5 × 36 cm (23¾ × 14¼ in)
Amsterdam: Rijksmuseum (Vincent van Gogh Foundation)

Although a considerable number of drawings survive from Van Gogh's schooldays, it was only from the beginning of 1881 that he began to draw seriously as an adult, commencing with copies of prints and reproductions of old masters, but soon taking his sketch-book out into the street and the country. When he was living in The Hague and studying art under his cousin Anton Mauve, he found admirable models in the old men and women, known as the 'orphans', who lived in the almshouses there. As he wrote to Theo, 'They call them, very expressively, *orphan* men, and *orphan* women. I was interrupted in the writing of this letter by the arrival of my model, and I worked with him till dark. He wears a large old overcoat, which gives him a curiously broad figure. I think you would like this collection of almshouse men in their Sunday and everyday clothes.' Twenty-six of these drawings have survived, all of them showing the strong, emphatic lines and economy of detail typical of Van Gogh's drawings.

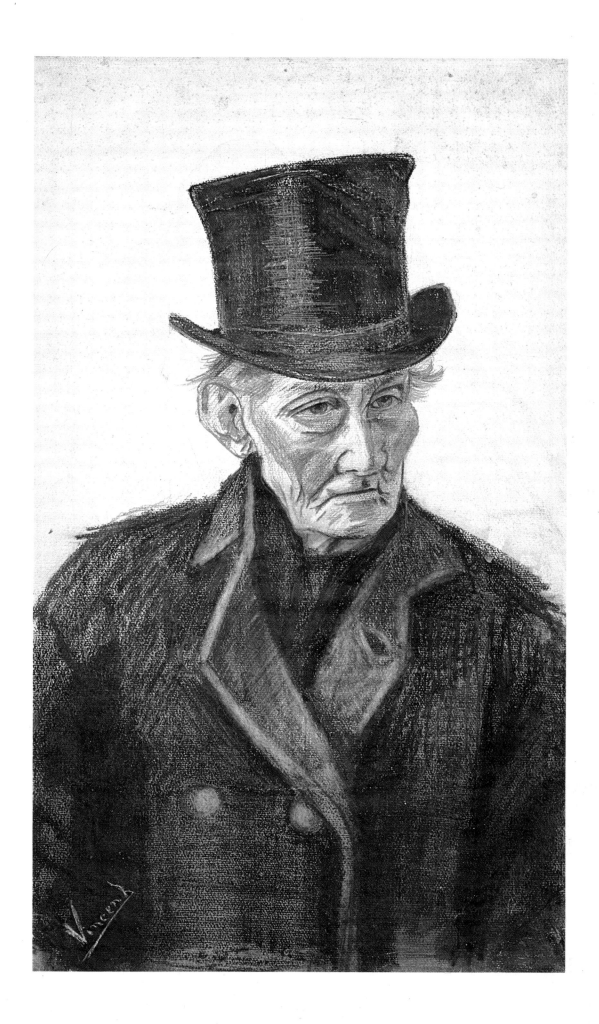

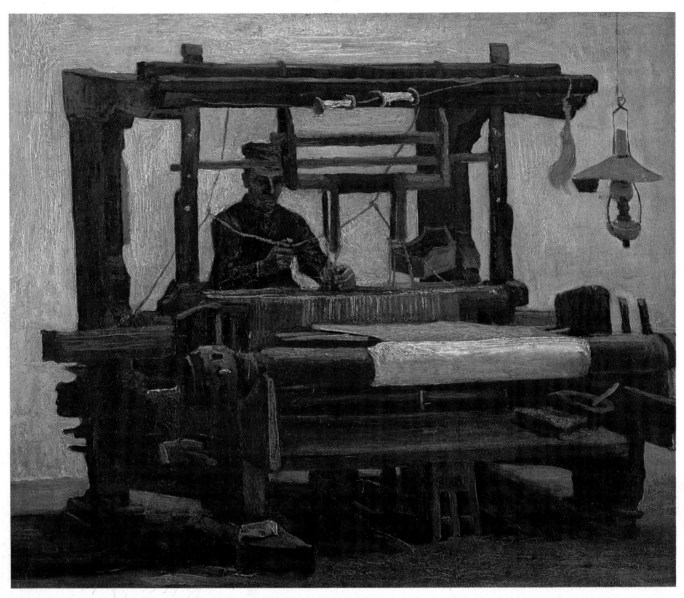

The weaver
May 1884.
Oil on canvas
70 × 85 cm (27½ × 33½ in)
Otterlo: Rijksmuseum (Kröller-Müller
Collection)

As early as 1880 Van Gogh had
expressed an interest in weavers,
whom he had first seen working in
Belgium, and between March and
July 1884 at Nuenen he produced
nine paintings and some 20
drawings on this subject. In part it
stemmed from his deep feeling for
working men, in part from his
admiration for artists such as Jean-
François Millet (1814–75), who had
specialized in unsentimental
depictions of peasant labour. On
1 May he wrote, 'I am working on a
rather large picture of a weaver, the
loom seen from the front – the little
figure a dark silhouette against the
white wall.' The command of
perspective and the dramatic quality
of the composition suggest the
extent to which his constant
application to the problems of basic
technique had begun to yield fruit.

Houses in Antwerp
December 1885
Oil on canvas
44 × 33.5 cm (17¼ × 13¼ in)
Amsterdam: Rijksmuseum (Vincent
van Gogh Foundation)

On 27 November 1885 Van Gogh
arrived in Antwerp. He rented a
room near the station at 194 rue des
Images, and he decorated it with
Japanese prints. 'I want to tell you,'
he wrote to Theo, 'that I am glad
that I came here. Last week I
painted three more studies, one of
the backs of old houses seen from
my window.' In fact he intended
doing a whole series of views of the
city, with the object of 'selling them
to foreigners who want a view of
Antwerp'. The project, if started,
was never completed; it is doubtful,
in any case, if tourists would have
been interested in pictures showing
the backs of ramshackle houses in a
poor district of the city. What is
apparent in this work, with its
simplified, lightened colour and
emphatic lines, is the influence
which Japanese prints were having
on his art. This would be
strengthened when he moved to
Paris a month or so later (indeed, it
was thought for many years that
this painting was from Van Gogh's
Paris period).

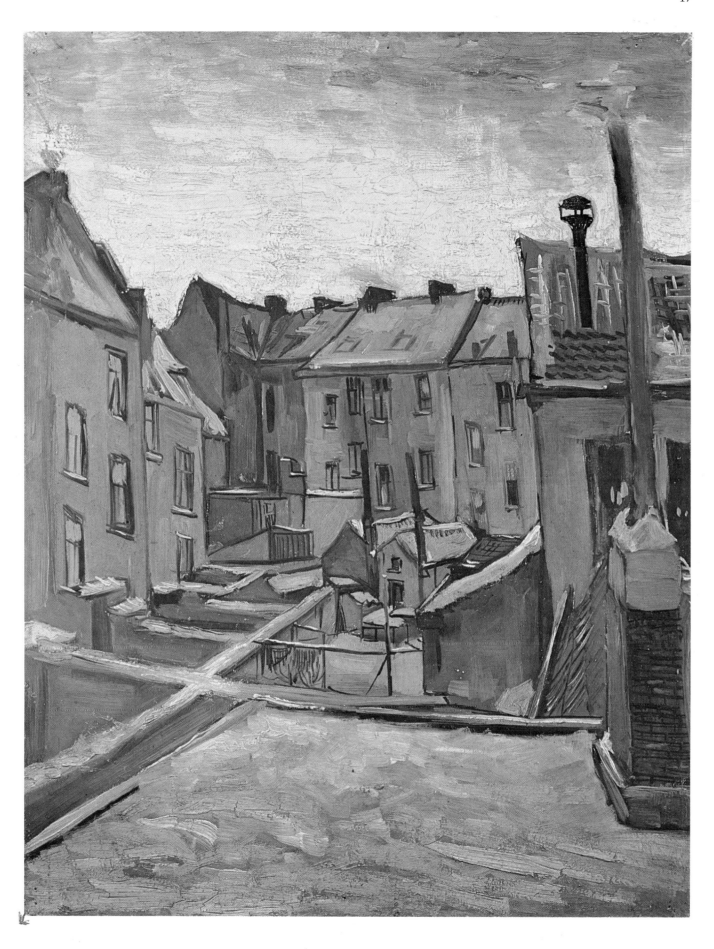

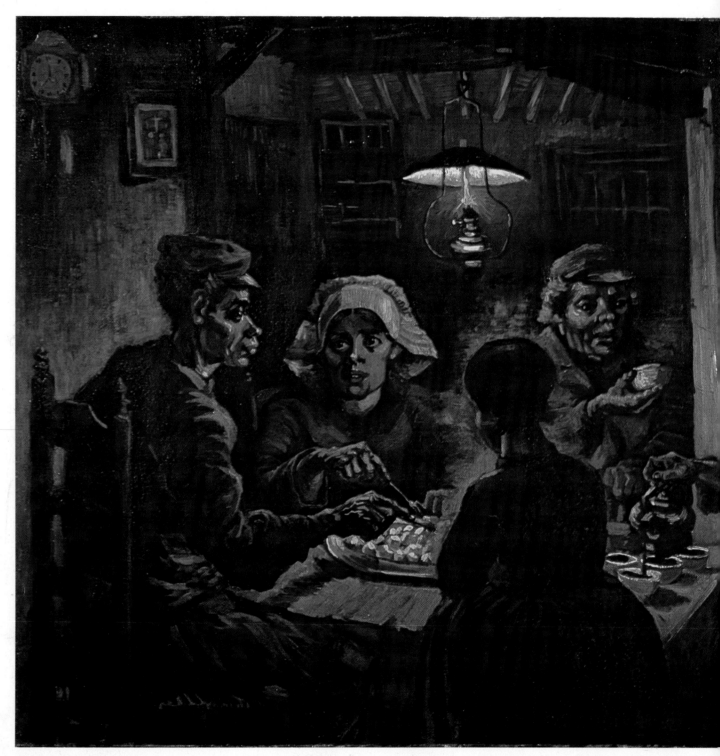

The potato-eaters
September–October 1885
Oil on canvas
82 × 114 cm (32¼ × 45 in)
Amsterdam: Rijksmuseum (Vincent
van Gogh Foundation)

Van Gogh's concern with the life of
the peasantry and with the
countryside generally found
expression in 1885 in a project for a
painting showing a group of people
at a table eating their evening meal.

Van Gogh rightly considered this to
be the most ambitious and the most
successful picture he had painted so
far in his career. The idea was not
entirely original: Josef Israels
(1824–1911), the leading Dutch
painter of his day and one of Van
Gogh's heroes, specialised in simple
scenes of working-class life, and in
1884 had exhibited The frugal meal,
which depicted a similar scene. This
had been made into a print by
Goupil, the art firm which employed

Theo van Gogh. In April Vincent
wrote to his brother: 'I have tried to
emphasize that those people, eating
their potatoes in the lamplight, have
dug the earth with those very hands
they put in the dish, and so it
speaks of manual labour, and how
they have honestly earned their
food. . . . It would be wrong, I think,
to give a peasant picture a certain
conventional smoothness. . . .
Painting peasant life is a serious
thing, and I should reproach myself

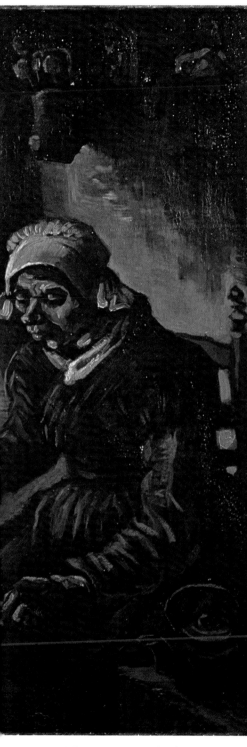

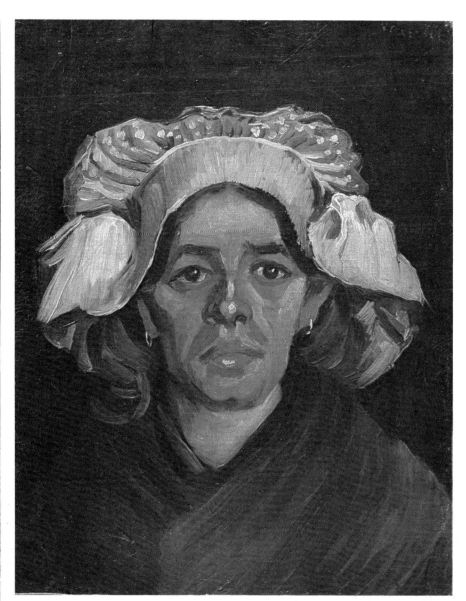

Head of a peasant woman
March 1885
Oil on canvas
45 × 36 cm (17¾ × 14⅛ in)
Amsterdam: Rijksmuseum (Vincent
van Gogh Foundation)

To prepare for *The potato-eaters*,
Van Gogh made studies of the heads
of the figures he would include in it,
painting at least 30, and drawing as
many more. Of the surviving
examples, this study, dark in
tonality but painted with strong,
decisive brush-strokes, is one of the
most outstanding. The head appears
in a slightly more animated version
as the second from the left in the
completed painting of *The potato-
eaters*. His choice of colours was
deliberate, as he explained to Theo:
'I think the best way to express
form is with an almost monochrome
colouring, the tones of which differ
principally in intensity and value.'

if I did not try to make a picture
which will raise serious thoughts in
those who think seriously about art
and life.' In part, too, the picture is a
further reflection of Van Gogh's
admiration for Millet, whose work
he knew from prints Theo sent him.

The Impact of Paris

For the 33-year-old Dutchman, now intent on a career as an artist, Paris was to offer revelations of a kind which would have been impossible during his earlier stay in that city. Theo had become a successful art-dealer, on friendly terms with many avant garde artists and aware of the vital events which were taking place in the world of painting. By now the work of the Impressionists had become accepted, and artists such as Renoir, Pissarro, and Monet were recognized as painters of distinction. At the same time, however, two clear reactions against Impressionism had become apparent. On the one hand Cézanne, Seurat, Signac, and others were trying to bring back into art a new sense of structure and formalism, rejecting as too amorphous and romantic the soft luminosity of painters such as Renoir or Monet. On the other hand there was becoming evident a tendency to rehabilitate colour in painting, not for its descriptive but for its emotive value.

During his two-year stay in Paris – a period about which less documentation is available than any other, for the simple reason that, living with Theo, he had no occasion to write to him – Van Gogh was transformed from a provincial artist into a cosmopolitan one. Until his arrival there he had little first-hand experience or even knowledge of Impressionism, and it was this which he first devoured with an enthusiasm and hysterical fervour which reduced some of his new friends to a state almost of collapse. The English painter A. S. Hartrick, who shared his studio with a friend, returned one day to find the latter with his head wrapped in a towel soaked in vinegar, complaining 'That terrible man [Van Gogh] has been here waiting two hours for you, and I can't stand it any more.'

Of the Impressionists the two who most influenced Van Gogh were Jean-Baptiste Guillaumin and the fatherly 60-year-old Camille Pissarro. From them and others he learnt new attitudes to light and colour; he abandoned the sombre tonality of his Dutch works in favour of a new brightness and vivacity. Instead of painting peasants he started to paint flowers, landscapes, street scenes. Under the influence of Paul Signac he became involved with the technique of Pointillism.

There were, however, more significant influences at work. In the autumn of 1886 Theo introduced his brother to Paul Gauguin. Overbearing, rough in manner, and utterly convinced of the rightness of his own artistic ideas, Gauguin both in his life and his work was the antithesis of the Impressionists. Newly returned from Pont-Aven in Brittany, he had come virtually to make a religion of colour, divorcing it from its representational functions and converting it into a language of emotion and feeling. It was from Gauguin that Van Gogh took the final element of that fiery amalgam of line, form, and colour into which his personal and individual style evolved.

The remarkable thing about Van Gogh's stay in Paris, however, lies not so much in the influences which were exerted on him as in the way he managed to control them. After all, although in his thirties, he was an unsophisticated, provincial Dutchman, with very little experience of the world and with scarcely any formal artistic training. He had been brought into contact with painters of considerable fame and reputation – men such as Pissarro, Monet, Cézanne; he had established friendship with others, notably Signac and Gauguin, who had strong personalities, clearly defined theories, and were full of didactic fervour. From all of these, however, Van Gogh took merely what he wanted: his creative personality remained totally his own.

By the winter of 1887 Van Gogh was tiring of Paris. He found city life exhausting, and he was depressed by the grey northern skies. On 20 February 1888 he took the train south: his destination – Arles.

The Moulin de la Galette
Spring 1886
Oil on canvas
38 × 46.5 cm (15 × 18¼ in)
East Berlin: Nationalgalerie

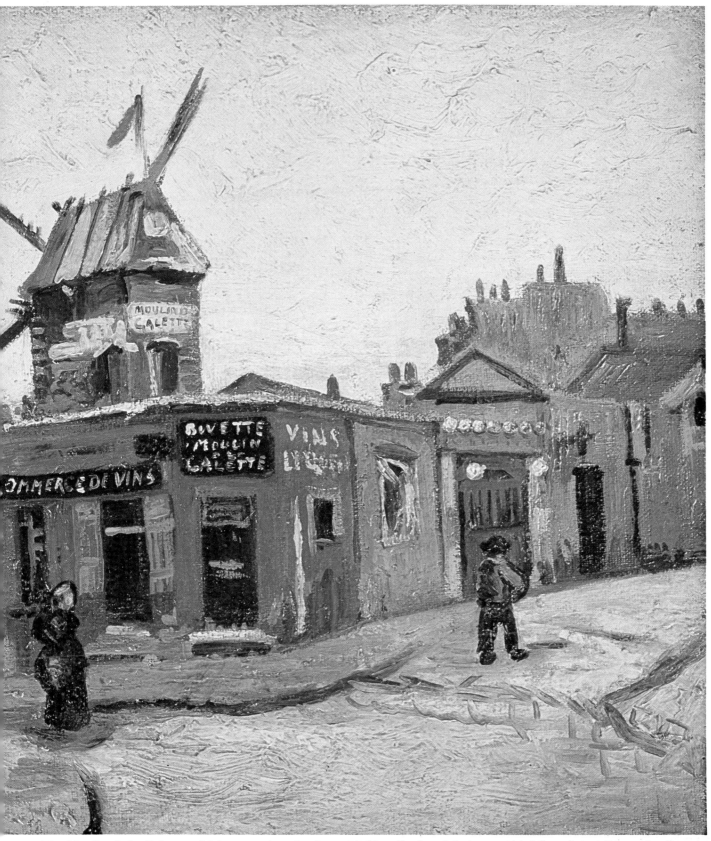

The Moulin de la Galette, which
crowned the heights of the Butte
Montmartre, overlooked a dance hall
of the same name that had long been
a favoured subject for painters
(Renoir had painted a picture of its
interior in 1876). Van Gogh painted
several views of the mill, always
emphasising the rustic air of the
building, and of the surrounding
streets and allotments. At this time
he and Theo were soon to move into
a third-floor flat at 54 rue Lepic, not
far from the mill. Although Van
Gogh was by now experimenting
with brighter colours and simpler
composition, neither development is
yet apparent in this work.

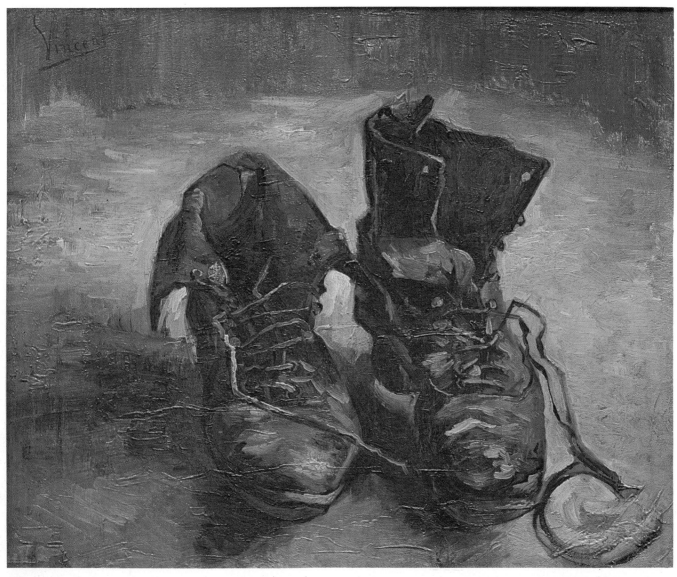

Boots with laces
Late 1886
Oil on canvas
37.5 × 45.5 cm (14¾ × 18 in)
Amsterdam: Rijksmuseum (Vincent van Gogh Foundation)

Even though excited by the life of Paris, and by the new kinds of artistic experience which were being made available to him, Van Gogh retained the feeling and sentiments about the life of working people which had dominated his life in Holland. There is an obvious sense of symbolism in these worn and creased boots, redolent perhaps of the personality of their absent owner, and painted in the rather dull range of colours which the artist had used at home in the parsonage of Nuenen. Empty boots, empty chairs, empty birds' nests: the theme was one to which Van Gogh would return frequently throughout his career.

The woman at the Café Tambourin
February 1887
Oil on canvas
55.5 × 46.5 cm (21¾ × 18¼ in)
Amsterdam: Rijksmuseum (Vincent van Gogh Foundation)

Agostina Segatori, the subject of this work, was the owner of the Café Tambourin in the Boulevard de Clichy in Paris, and had previously been an artist's model. She was for some time a friend of Van Gogh and may even have been his mistress. It was at the Tambourin that he organized an exhibition of Japanese prints (borrowed from a dealer) and then displayed a selection of his own works, together with those of some of his friends, including Louis Anquetin, Henri de Toulouse-Lautrec, and Émile Bernard. The show was not a success, although he had hoped that the café would become a centre for artists who thought and felt as he did. He

painted a number of pictures to decorate the walls (some of them can be seen in the background of this work), and had difficulty in getting them back when La Segatori went bankrupt at the end of 1887.

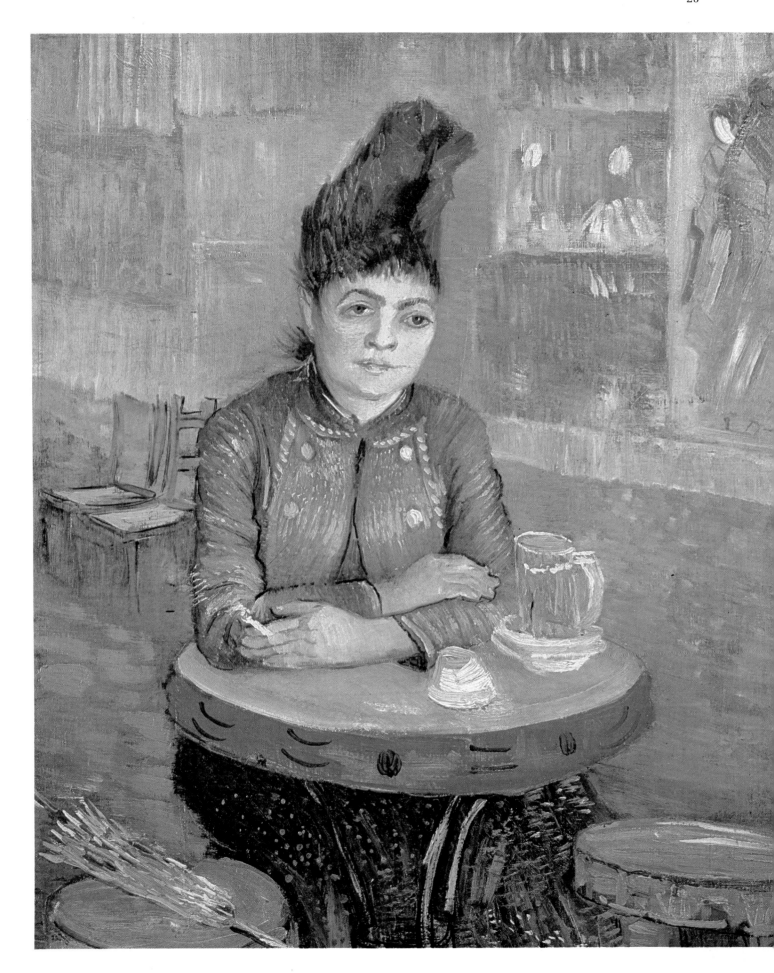

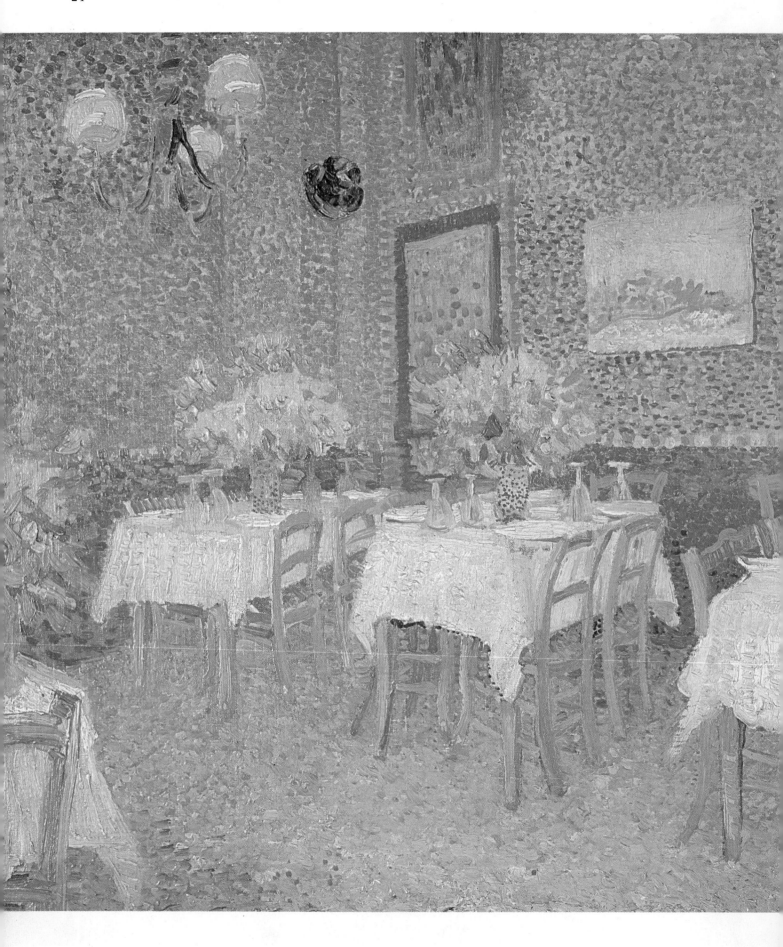

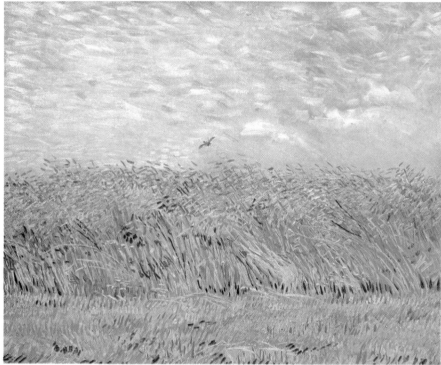

Interior of a restaurant
Summer 1887
Oil on canvas
45.5 × 56.5 cm (18 × 22¼ in)
Otterlo: Rijksmuseum (Kröller-Müller
Collection)

Clearly influenced by Pointillist
theories, especially in the handling
of the patterned wall and the dots
of colour which create the surface of
the floor and of the table-cloths, this
painting represents the point at
which Van Gogh came closest to
what was to be called the Neo-
Impressionist movement in Paris. It
is in many ways his most untypical
picture: 'As to Pointillist execution,'
he wrote to Theo, 'I think that it is a
real discovery, yet it is already to be
seen that this technique will now
become a universal dogma like any
other'. His response to such theories
was almost invariably instinctive
rather than reasoned; he employed
Pointillist technique not because he
subscribed to the 'scientific' theories
on which it was based but because
he thought it offered the chance of
achieving interesting new textures
and colours.

Lark over a wheatfield
Summer 1887
Oil on canvas
54 × 64.5 cm (21¼ × 25½ in)
Amsterdam: Rijksmuseum (Vincent
van Gogh Foundation)

Even though he was living in Paris,
Van Gogh was still concerned, as he
had been in Holland, with the cycles
of nature and the life of the fields,
which were within walking distance
of the flat in the rue Lepic. There is
apparent in a painting such as this,
however, a freshness, a brilliance of
handling, and a love for vigorous
brush-strokes that show the
influence which his friends in Paris
painters such as Signac, Seurat,
Gauguin, and Toulouse-Lautrec —
were having on him at this time.
What, above all else, is remarkable
in the painting is its extreme
simplicity: merely the rough
silhouette of a bird seen above a
mass of wheat bending in the wind.

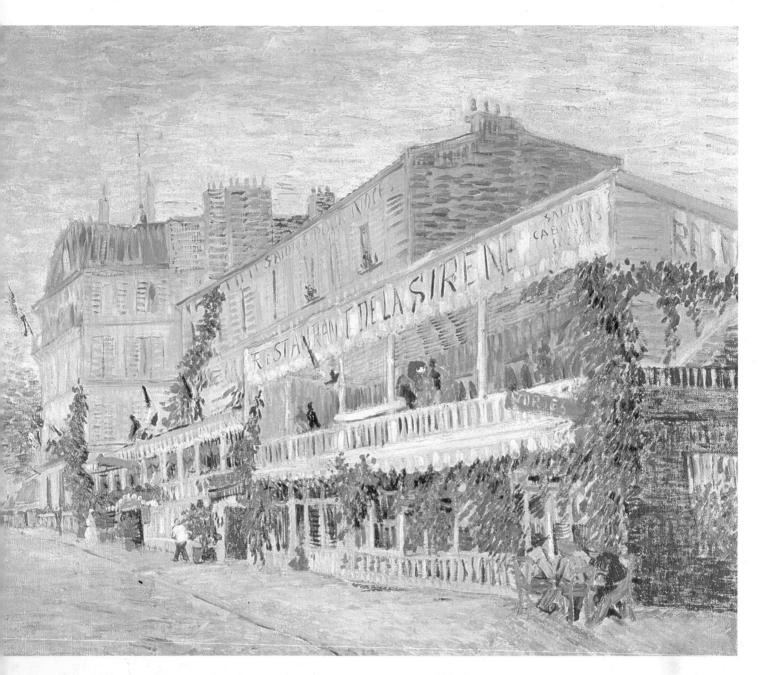

Restaurant de la Sirène
Summer 1887
Oil on canvas
57×68 cm $(22\frac{1}{2} \times 26\frac{3}{4}$ in)
Paris: Louvre

Asnières, on the banks of the Seine
north-west of Paris, had for long
been a favourite haunt of painters,
especially the Impressionists, and
Van Gogh was introduced to it by
Paul Signac, one of the founders of
the Pointillist movement, which
exploited the technique of building a
picture by means of laying down
small dots of different colours on the
canvas. They went on several
painting expeditions together in and
around Asnières and, Signac
recalled later, 'Van Gogh, dressed in

a workman's blue blouse, had
painted little dots of colour on his
sleeve. Sticking close to me, he
shouted and gesticulated,
brandishing his large, freshly
covered canvases, and getting paint
not only on himself but on passers-
by'. Signac was a persuasive and
highly intelligent person, and in
paintings such as this and the one
on page 24, with their small brush-
strokes and dots of colour, his
influence on his friend is very
apparent. But, although Van Gogh
found Pointillism interesting
theoretically, his temperament and
his developing attitude towards the
use of colour ensured that his
exploitation of this technique was
merely a passing phase.

Portrait of Père Tanguy
Autumn 1887
Oil on canvas
92 × 75 cm (36¼ × 29½ in)
Paris: Musée Rodin

It is not known who first took Van
Gogh to the shop of Père Tanguy in
the rue Clauzel, near the rue Lepic,
but his acquaintance with this old
colour-grinder was to be of great
value to him. Tanguy would often
accept paintings in exchange for his
artists' supplies. He was a real
character, who had fought on the
side of the Commune during the
troubles of 1870–1, and he possessed
an artistic discernment far ahead of
his time, collecting works by
customers·of his such as Pissarro,
Cézanne, Gauguin, Renoir, and
Monet. He immediately took a fancy
to the young Dutchman (a fancy not
shared by his wife), who
reciprocated with his usual warmth.
Van Gogh did several paintings of
Tanguy in which he tried to express
the simple goodness and love of art
which radiated from the humble
tradesman. It is significant that Van
Gogh adorned the background with
some of those Japanese prints by
Hokusai and Hiroshige which were
beginning to have such an influence
on his own art. (This painting was
acquired after Van Gogh's death by
the great sculptor Auguste Rodin, an
early admirer of his work.)

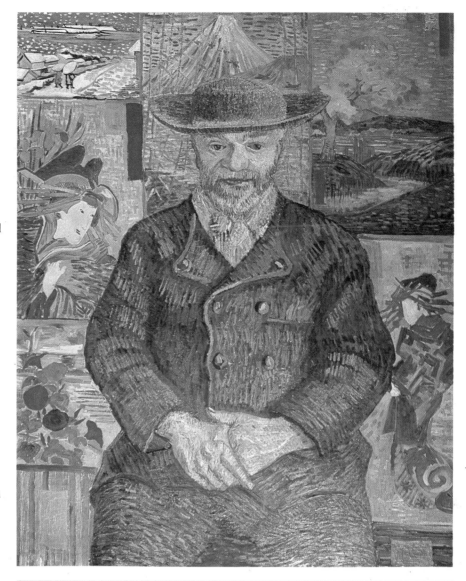

Still-life: apples
Summer 1887
Oil on canvas
45.5 × 61 cm (18 × 24 in)
Amsterdam: Rijksmuseum (Vincent
van Gogh Foundation)

Although Van Gogh's first painting
of apples had been done in Nuenen
a year or so earlier, this treatment of
a subject which had been popular
with Courbet, Renoir, and Cézanne
reflected the fervour with which he
was throwing himself into the
techniques of Impressionism. The
flurry of short brushstrokes,
radiating out from the centre of the
picture, and repeated within the
confines of each apple, not only
concentrates the eye on the
appearance of the objects, but
enhances the feeling of volume and
of rotundity. The artist is engaged in
a struggle to make the spectator feel
the *reality* of what he is painting.

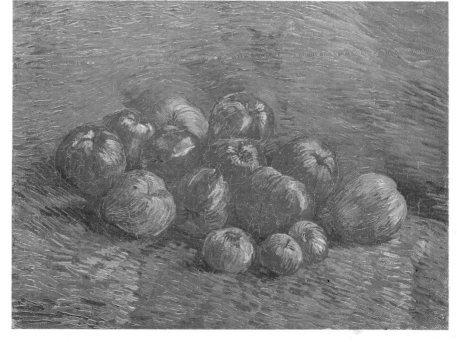

South to the Sun

It was Henri de Toulouse-Lautrec who had recommended Arles, an ancient town on the river Rhône just 25 km (15 miles) from the Mediterranean. With the arrival of spring and the blossom on the fruit trees, Van Gogh threw himself into a frenzy of work. It was all that he had expected: the vivid colours, the simple masses of the hills, the clearly defined outlines of the land (which put him in mind of the Japanese prints he so admired), the serenity of the people, with some of whom he immediately established friendly contact. He took long daily walks through the countryside, finding sites which appealed to him, and then returning to them with easel, paints, and canvas to combine his first impressions with the actuality he saw before him. 'I must warn you,' he wrote to Theo, 'everyone will think that I work too fast. Don't believe a word of it. Is it not emotion, the sincerity of one's feelings for nature, that draws us? And if these emotions are sometimes so strong that one works without knowing one does so, when sometimes the brush-strokes come with a sequence and coherence like words in a speech or letter, then one must remember that it has not always been so, and that in time to come there will again be dreary days, devoid of inspiration. So one must strike while the iron is hot.'

In spite of his prodigious output – in 15 months he painted more than 200 landscapes, portraits, and still-lifes, as well as producing an enormous mass of drawings – there was nothing slapdash or incoherent about his work. The compositions were vigorous, and often innovatory; the lines incisive and sure; the colours – vermilion, an astringent emerald green, sunshine yellow, deep blue – vivid and vibrant. The concern with light, which he had picked up from the Impressionists, intensified and it was reinforced by a new and fervent fascination with the possibilities of colour freed from dependence on observed reality.

Life, however, was not all painting and inspiration. Very soon complications of a different kind began to occur. Eating little and drinking heavily, Van Gogh began to suffer from fainting fits, and first mentioned to his brother those fears of insanity which were beginning to oppress him. Then there was the complicated business of his relationship with Gauguin, whom he had persuaded to come and live with him in Arles, and who arrived there on 20 October 1888. Hysterically overjoyed to find someone whom he admired and with whom he could discuss his own ideas and ambitions, Van Gogh's initial reactions were overwhelming. Gauguin was appalled at the prospect of sharing a home with one who was so emotional, so untidy, so impractical. Tensions grew; there were violent scenes, drunken brawls. In December Gauguin wrote to Theo (who was his dealer) 'Everything considered, I am obliged to return to Paris: Vincent and I simply cannot live together without trouble, owing to the incompatibility of our characters.'

Before that could happen, however, there was high drama. It was reported thus in the local paper *Le Forum Républicaine* on 24 December: 'Last Sunday night at half past eleven, a painter named Vincent van Gogh, a native of Holland, appeared at the *maison de tolérance no. 1* [a brothel], asked for a girl called Rachel, and handed her his ear with the words, "Keep this object carefully". Then he disappeared. The police, informed of these happenings, which could be attributed only to an unfortunate maniac, looked next morning for this individual, whom they found in bed with scarcely a sign of life.' Taken to hospital, Van Gogh remained unconscious for three days. There he was visited by Theo, who had come down from Paris, and by local friends such as Joseph Roulin, a postal official. Gauguin returned to Paris; when Vincent was discharged on 7 February 1889 he returned to an empty house – and a good deal of hostility from people in the neighbourhood.

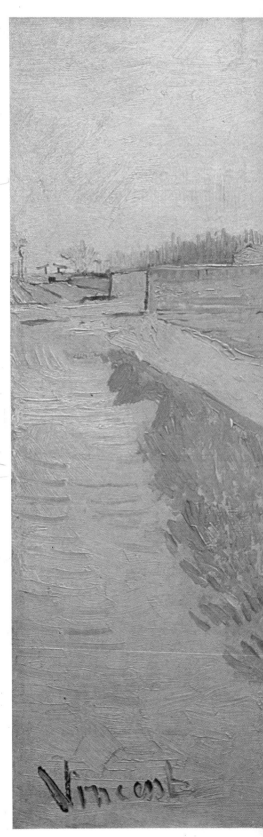

Langlois bridge with the road along the canal
March 1888
Oil on canvas
58.5 × 73 cm (23 × 28¾ in)
Amsterdam: Rijksmuseum (Vincent van Gogh Foundation)

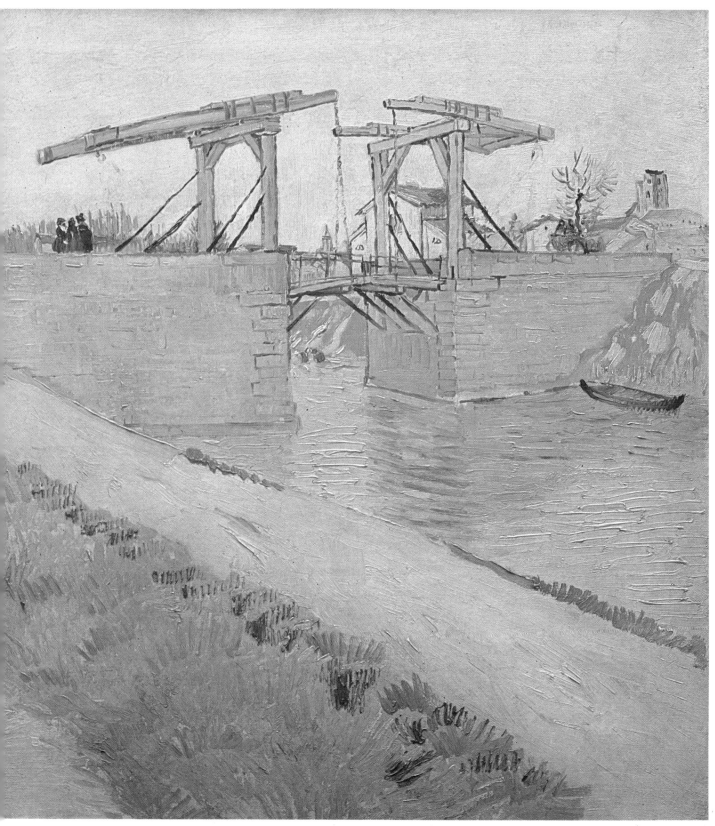

One of Van Gogh's most cherished beliefs was that to grasp the real nature of things you had to look at them and paint them for a very long time. This drawbridge, which spanned the canal from Arles to Port-de-Bouc, became a favourite subject for him. He painted three versions of it in oils, as well as a water-colour, and he also produced a number of drawings of it. Bridges often appeared in Japanese prints, and in his treatment of the subject Van Gogh relied heavily on that tradition, emphasising the diagonals, using strong contrasts of colour, and heavily accenting the outlines. Although the original bridge was replaced by a new one in 1910, a replica of 'Van Gogh's Bridge' was built near Arles in 1962.

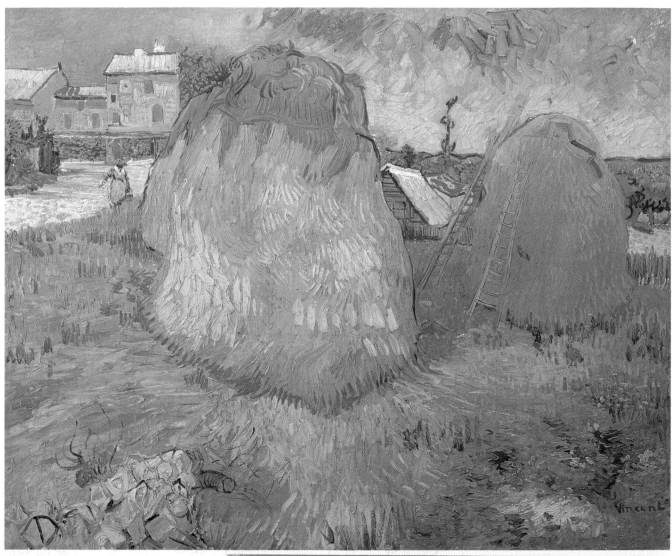

Orchard with view of Arles
April 1889
Oil on canvas
50.5 × 65 cm (20 × 25½ in)
Amsterdam: Rijksmuseum (Vincent
van Gogh Foundation)

Fruit trees in blossom had a very
powerful appeal for Van Gogh, and
he made many paintings of the
subject during the period at Arles. It
was probably this particular one
which he chose to be one of several
works that he sent to Brussels after
being invited by a group of modern
artists, who called themselves 'The
XX', to participate in one of their
exhibitions. He clearly thought very
highly of this work. There are no
signs here of the visual turbulence
which agitated other works he was
to start during the next few months,
and it expresses perfectly the
lushness of the Provençal
countryside in high spring.

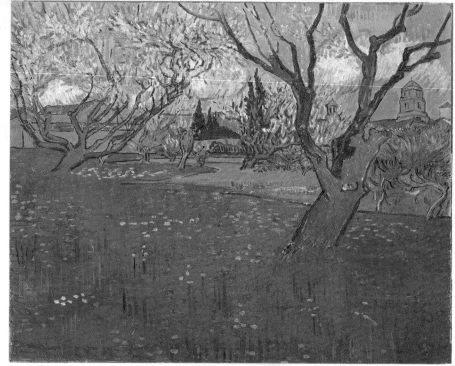

Haystacks in Provence
June 1888
Oil on canvas
73 × 92.5 cm (28¾ × 36½ in)
Otterlo: Rijksmuseum (Kröller-Müller
Collection)

The idea for this painting (left) first
struck Van Gogh on 12 June, and
four days later he wrote to Theo:
'Today I am sending you three
drawings by post. You will think the
one of the ricks in the farmyard too
bizarre, but it was done in a great
hurry for a picture, and it is to show
you the idea'. Actually four
drawings have survived, in all of
which figures play a more important
part than does the single woman in
this painting. It seems almost as
though his first intention had been
to produce a Millet-like painting of
women working in a farmyard, but
had then become more interested in
the texture and shape of the
haystacks, which he paints with
heavy brush strokes to emphasise
their rich texture and solid form.

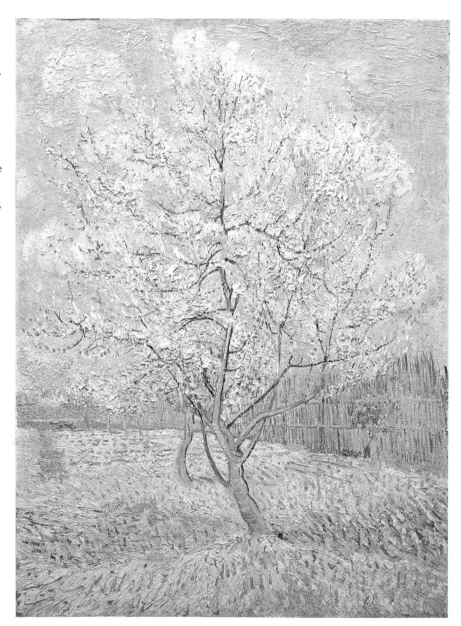

Orchard in blossom: pink peach tree
April–May 1888
Oil on canvas
81 × 62 cm (32 × 24½ in)
Amsterdam: Rijksmuseum (Vincent
van Gogh Foundation)

Van Gogh started painting fruit
orchards in blossom at the end of
March – only a month after his
arrival in Arles – and eventually
completed an impressive series of
paintings of peach, apricot, plum,
and pear trees, some of which were
intended to go together to form
triptychs. He had already painted

one pink peach tree, which he sent
to the widow of his friend and
cousin, the painter Anton Mauve,
who had just died at the age of 50
and who had done much to help him
in the early part of his career. He
therefore needed another version to
serve as the centrepiece. This
painting – which gave him a great
deal of trouble – is the result.
Although the theme is one which
had been used by Impressionist
painters such as Monet, Van Gogh
adopted a much more decorative
approach in which his passion for
Japanese art is clearly evident.

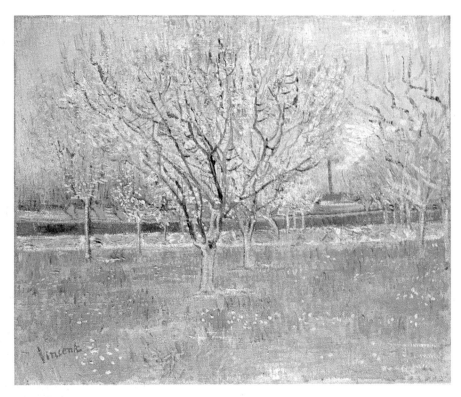

A corner of the orchard: plum trees
April 1888
Oil on canvas
55 × 65 cm (21¾ × 25½ in)
Edinburgh: National Gallery of
Scotland

'At the moment I am working on
some plum trees, yellowish white,
with thousands of black branches',
Van Gogh wrote on 9 April. This
work was meant to be part of a
series of nine although, as he wrote
to Theo 11 days later, 'I have ten
orchards now, not counting three
little studies, and one big one of a
cherry tree, which I've spoiled'. The
clear light of Provence adds to the
sharp black branches a sense of the
emphatic, even the dramatic, which
endows the painting with an
evocative charm, and which, as in
the other orchard paintings, reveals
the oriental qualities that now began
to imbue Van Gogh's work.

The harvest in La Crau
June 1888
Oil on canvas
72.5 × 92 (28½ × 36¼ in)
Amsterdam: Rijksmuseum (Vincent
van Gogh Foundation)

During the early summer of 1888
Van Gogh spent several days
painting in La Crau, an extensive
plain near Arles that reminded him
of landscapes painted by the 17th-
century Dutch artist Philips de
Koninck. He did several drawings in
preparation for this painting, but he
found in working on it that he
shared some of Cézanne's difficulties
in that sometimes his touch was
sure, sometimes 'clumsy' (as he
described it). That quality is
certainly not evident in the finished
painting, in which accurate
perspective and a feeling for rich,
sun-lit landscape are brilliantly
expressed in flowing brushwork.

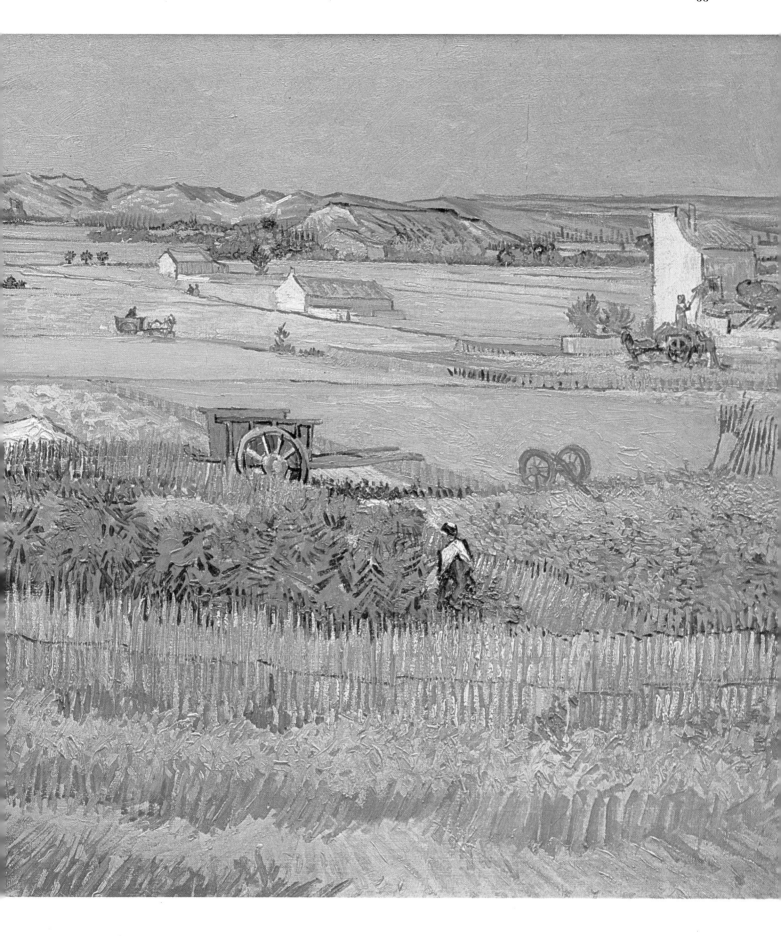

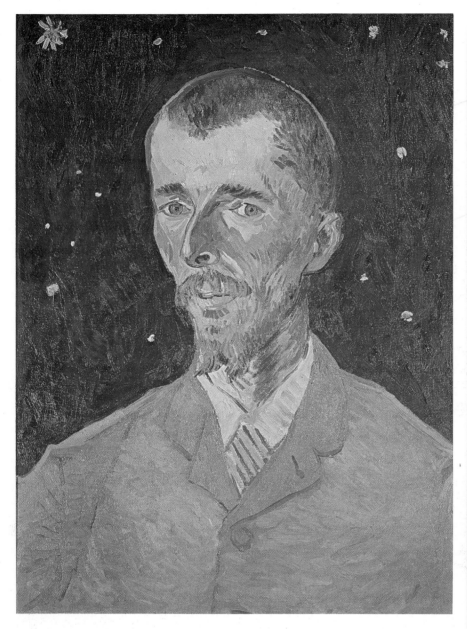

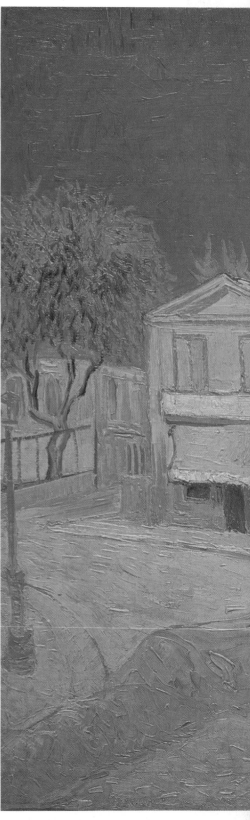

Portrait of Eugène Boch
September 1888
Oil on canvas
60 × 45 cm (23½ × 17¾ in)
Paris: Louvre

In September 1888 Van Gogh met a Belgian poet and painter, Eugène Boch, who was living at Fontevielle, near Arles, but who came originally from the Borinage, where Van Gogh had worked with the miners seven years before. In this remarkable portrait he started seriously to put into practice his new concept of using colour to express feeling rather than to record visual experience. He wrote to Theo: 'To finish the painting, I'm now going to be an arbitrary colourist. I am exaggerating the fairness of the hair, I even get to orange tones, chromes, and pale citron-yellow. Behind the head, instead of painting the ordinary wall of the main room, I paint infinity. . . . In a picture I want to say something comforting, as music is comforting. I want to paint men and women with something of the eternal which the halo used to symbolise and which I seek to convey by the actual radiance and vibration of my colouring.'

Vincent's house at Arles
September 1888
Oil on canvas
76 × 94 cm (30 × 37 in)
Amsterdam: Rijksmuseum (Vincent van Gogh Foundation)

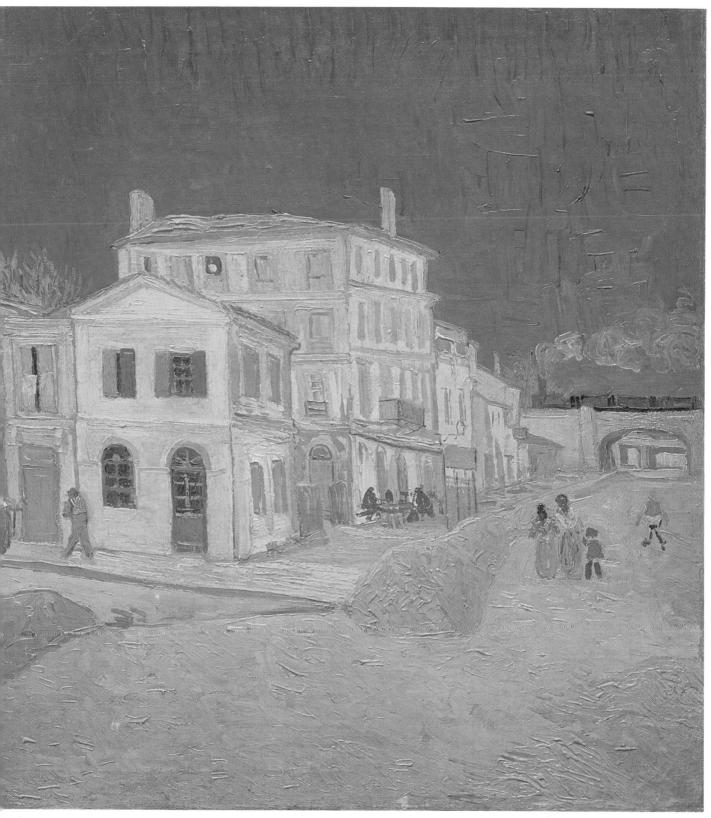

On leaving the Café de l'Alcazar, where he had spent his first few weeks in Arles, Van Gogh rented the wing of a house nearby at 2 Place Lamartine. He saw it as a 'house of friends', a 'studio of the south', and asked Gauguin to join him (Gauguin in fact arrived in October). At first he did not have enough furniture to live there, but he eventually took up residence on 2 September 1888. Just behind the house was a café where he had dinner every night and which he painted on several occasions (see next page). He was deeply impressed by the colour of his own house, and writing to Theo he commented: 'The subject is frightfully difficult, but that is just why I want to conquer it. It's terrific, these houses yellow in the sun, and the incomparable freshness of the blue. And all the ground is yellow too.'

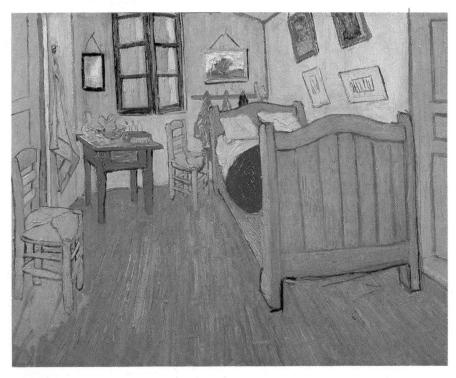

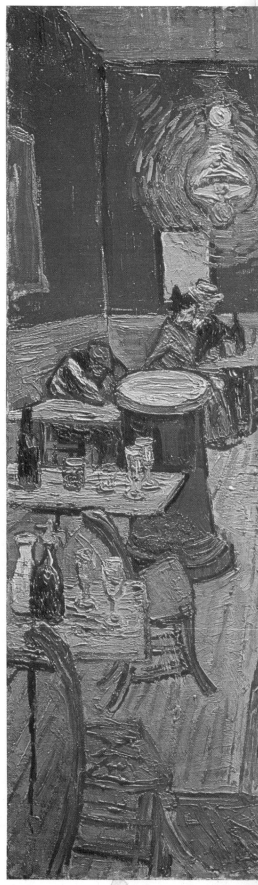

Vincent's bedroom at Arles
October 1888
Oil on canvas
72 × 90 cm (28¼ × 35½ in)
Amsterdam: Rijksmuseum (Vincent
van Gogh Foundation)

Van Gogh was entranced by his
house on the Place Lamartine and
did a series of pictures of the
interior. 'I had a new idea in my
head, and here is the sketch. This
time it's just simply my bedroom,
only here colour is to do everything,
and giving by its simplification a
grander style to things, to be
suggestive here of *rest* or of sleep in
general. In a word, to look at the
picture ought to rest the brain, or
rather the imagination. The walls are
pale violet. The ground is of red
tiles. The wood of the bed and the
chairs is the yellow of fresh butter,,
the sheets and pillows very light
greenish lemon. The coverlet scarlet.
The window green. The toilet table
orange, the basin blue. The doors
lilac. The frame – as there is no
white in the picture – will be white.
You see how simple the conception
is. The shadows, both real and
reflected, are suppressed, it is
painted in free, flat washes like the
Japanese prints.' Among the pictures
visible on the right-hand wall of the
room is the portrait of Eugène Boch
(see page 34) he had finished only
the month before.

Night café at Arles
September 1888
Oil on canvas
70 × 89 cm (27½ × 35 in)
New Haven (Conn.): Yale University
Art Gallery

One of Van Gogh's favourite haunts
in Arles was the all-night café in the
Place Lamartine, where people who
were too drunk or too poor to find a
bed could stay. He sat up for three
nights painting this picture, sleeping
during the day, and found the
experience exhilarating. The
extraordinary violence of the colours
in the painting represented what he
called 'the terrible passions of
humanity'. He wrote: 'I often think
that the night is more alive, and
more richly coloured, than the day.
The room is blood red and dark
yellow with a green billiard table in
the middle; there are four lemon-
yellow lamps with a glow of orange
and green. Everywhere there is a
clash and contrast of the most alien
reds and greens, in the figures of the
little sleeping tramps, in the empty,
dreary room in violet and blue. The
blood red and the yellow green of
the billiard table, for instance,
contrast with the soft, tender Louis
XV green of the counter, on which
there is a pink nosegay. The white
coat of the proprietor on vigil in a
corner of this blaze turns lemon
yellow, or pale, luminous green.'

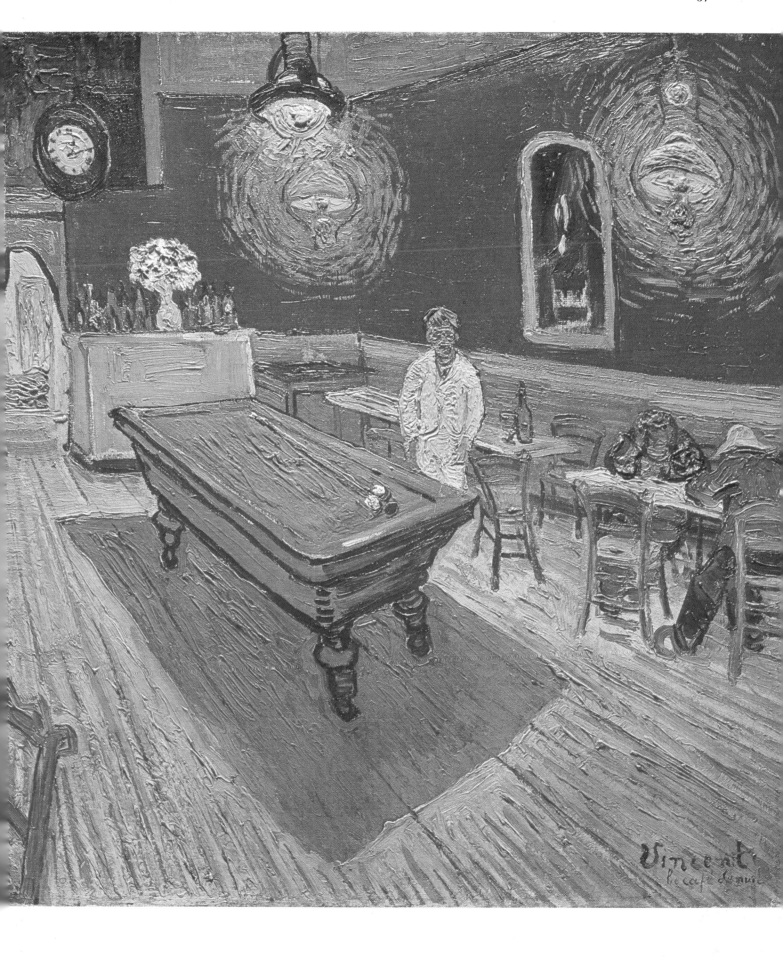

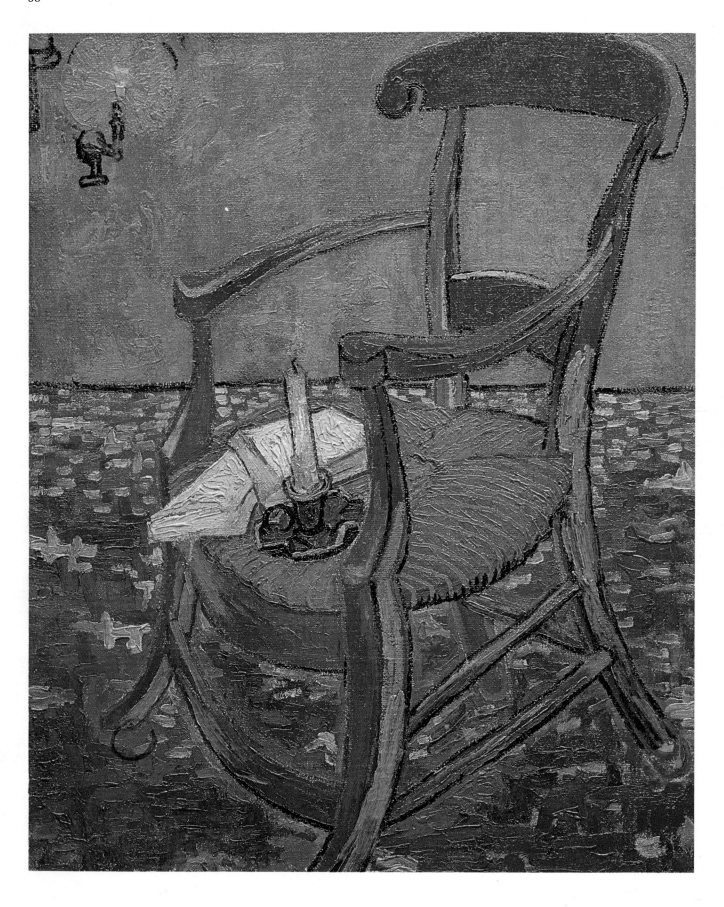

Gauguin's chair
December 1888
Oil on canvas
90.5 × 72 cm (35¾ × 28¼ in)
Amsterdam: Rijksmuseum (Vincent van Gogh Foundation)

Paul Gauguin had arrived in Arles, on Van Gogh's invitation, towards the end of October, but it soon became apparent that the relationship between the two was not going to be an easy one. Gauguin did a portrait of Van Gogh painting sunflowers; but although Van Gogh was working on a number of portraits, he did not attempt to reciprocate, either because Gauguin did not have the patience to sit for him or, more likely, because Van Gogh was daunted by his friend's aggressive and critical attitude. By painting Gauguin's chair he seemed to be offering a substitute. Four weeks after finishing this picture he wrote about it to the critic Albert Aurier: 'I also owe a great deal to Paul Gauguin, with whom I worked for several months at Arles, and whom I also knew in Paris, a friend who makes you feel that a good picture should be the equivalent of a good deed. . . . A few days before we separated, when illness forced me to enter a hospital, I tried to paint "his empty seat". It is a study of his armchair in sombre reddish-brown wood, the seat of greenish straw and, in place of the absent one, a lighted candle and some modern novels. I beg you, if the occasion presents itself, to look at this study again, which is completely done in broken tones of green and red.'

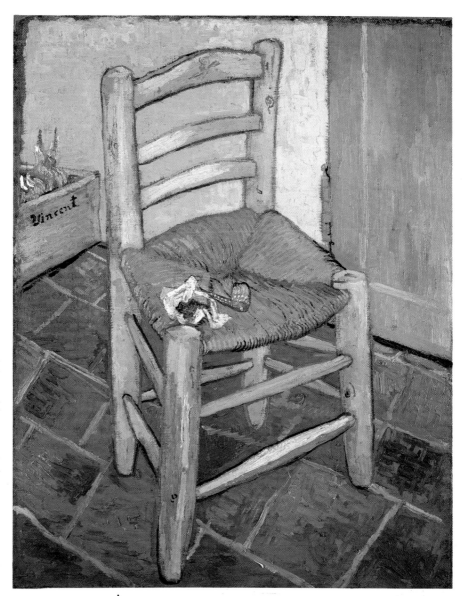

Vincent's chair with pipe
December 1888–January 1889
Oil on canvas
93 × 73.5 cm (36½ × 29 in)
London: Tate Gallery

Van Gogh obviously thought of the two 'portraits' he did of his own and Gauguin's chairs as symbolic of their two personalities, and of the links which he had hoped would unite them. He derived the idea initially from a wood engraving by the English artist Luke Fildes which had appeared in *The Graphic* in December 1870 (and of which he had a copy). It was entitled *The Empty Chair, Gad's Hill* and showed a chair at the desk in Charles Dickens' study, shortly after the novelist's death. 'In these two studies, as in others,' Van Gogh wrote, 'I have tried for an effect of light by means of clear colour.' The pipe and the tobacco pouch add a note of poignancy to a picture remarkable for the austerity of its composition and the clarity of its colours.

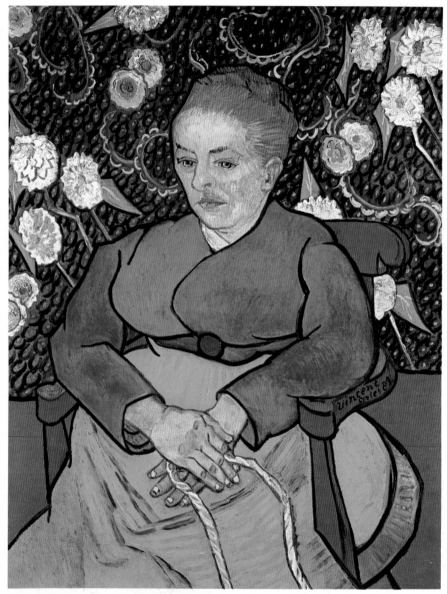

Madame Roulin: la berceuse
January 1889
Oil on canvas
93 × 74 cm (36½ × 29¼ in)
Radnor (Penn.): Walter H.
Annenberg Collection

Madame Augustine Roulin, the wife of the postal official, was one of Van Gogh's favourite models in Arles. He began this portrait of her in December 1888, but work on it was disrupted by his collapse following the occasion on which he cut off part of his ear after quarrelling with Gauguin. The picture was originally intended to show Mme Roulin rocking her baby's cradle (whence the subtitle: *berceuse* = lullaby). The style of the work shows very clearly the influence of Gauguin, with its broad areas of flat colour divided by black outlines. Later he referred to this in a letter to his friend the painter Émile Bernard, 'As you know, once or twice when Gauguin was in Arles, I let myself go into abstraction, for instance in *La berceuse* or *The woman reading a novel*. Abstraction seemed to me a charming path. But it's enchanted ground, and soon one finds oneself up against a stone wall.'

The postman Roulin
January–February 1889
Oil on canvas
65 × 54 cm (25½ × 21¼ in)
Otterlo: Rijksmuseum (Kröller-Müller Collection)

Painted in large, flat planes and strong, simple colours, Van Gogh's portrait of Joseph Roulin commemorates one of his closest friendships in Arles. 'My friend the postman lives a great deal in cafés, and is certainly something of a drinker, and has been so all his life. But he is the very reverse of a drunkard, he is so natural, so intelligent when he gets excited about anything, and he argues with a forceful vigour, in the style of Garibaldi. There is something in him tremendously like Socrates.' He completed this portrait and another head in the same week. Although Roulin would not take a fee for posing, Van Gogh told Theo that he cost him more in food and drink than if he had done so. (Roulin was not in fact a postman but was employed at the railway station loading mail. He was immensely tall, and lived with his family in the street in which Van Gogh had lived when he first came to Arles.)

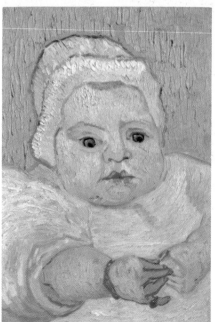

The baby Roulin
November–December 1888
Oil on canvas
35 × 24 cm (13¾ × 9½ in)
Washington: National Gallery of Art (Chester Dale Collection)

Van Gogh's affection for the family of Joseph Roulin is epitomised in this portrait of the latest addition to the family, the baby Marcelle, of whom he painted two almost identical portraits late in 1888. There was clearly a lot of frustrated parenthood in Van Gogh: he painted several pictures of mothers holding or suckling their babies, and he wrote wistfully of Roulin: 'It was touching to see him with his children, especially with the tiny one, when he made her laugh and jump on his knee and sang for her. His voice has a strangely pure and touching quality. . . .'

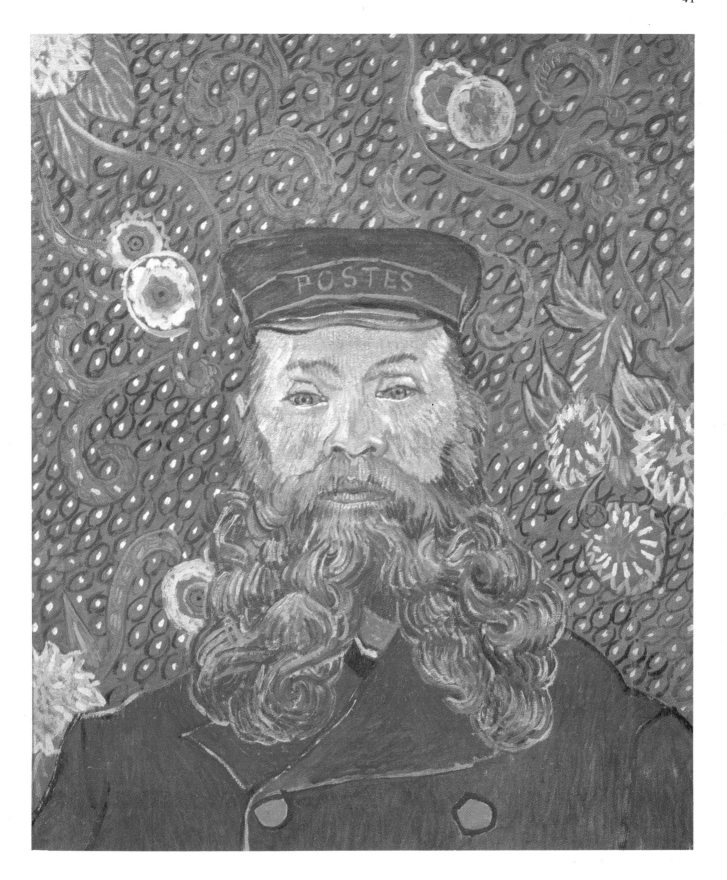

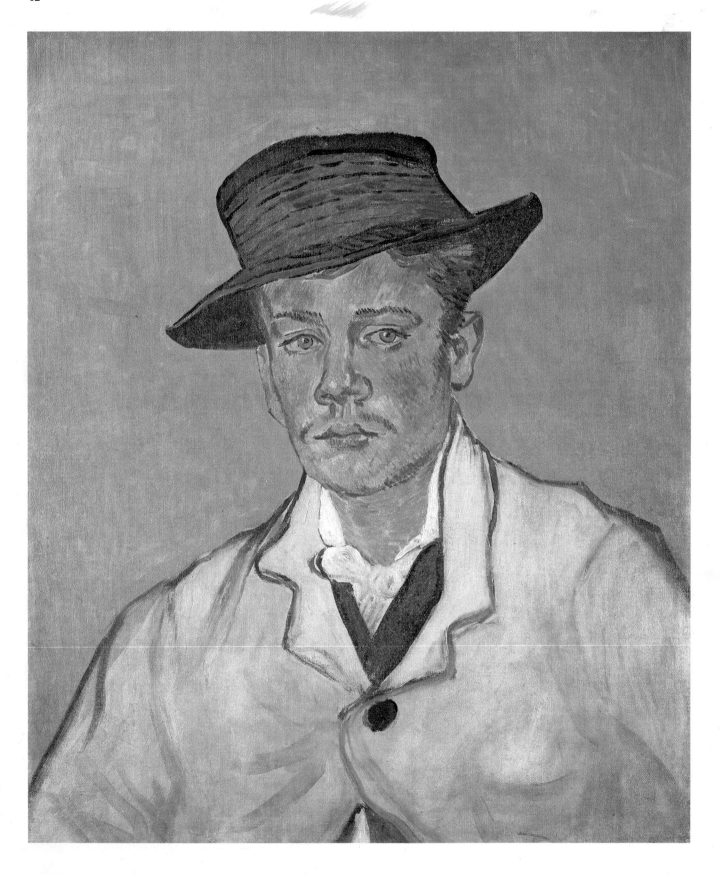

Portrait of Armand Roulin
November 1888
Oil on canvas
66 × 55 cm (26 × 21¾ in)
Essen: Museum Folkwang

Van Gogh painted two portraits of
Armand Roulin, the son of the
postman Joseph: one facing left,
which shows him looking his age
(16 years old), and this front-view
version, which makes him seem
older and more handsome. The
treatment is very simple, the colours
bright and straightforward. Van
Gogh has been especially successful
in catching the slightly sideways
look of the eyes, with their
suggestion of the defensiveness of
adolescence. The modelling of the
face involved the use of tiny brush
strokes of many individual colours
to produce characteristic flesh tints.

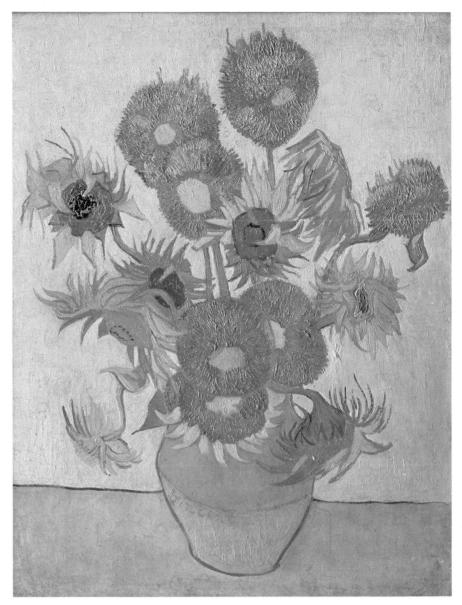

Vase with fourteen sunflowers
January 1889
Oil on canvas
95 × 73 cm (37½ × 28¾)
Amsterdam: Rijksmuseum (Vincent
van Gogh Foundation)

Sunflowers became for Van Gogh
the very epitome of the hot south,
the land which he loved with the
fervour which only one from a cold
climate could experience. In August
1889 he wrote to Émile Bernard: 'I
am thinking of decorating my studio
with half-a-dozen pictures of
sunflowers; a decoration in which
chrome yellow, crude or broken,
shall blaze forth against various
backgrounds of blue, ranging from
the very palest emerald up to royal
blue, and framed with thin strips of
wood painted orange – the sort of
effect of Gothic stained glass
windows.' There are six large

sunflower pictures surviving, but
two of these, including this one, are
replicas which he made in January
1889 after his nervous collapse,
following the incident of the cut ear.
It has been suggested that the first
version of this (painted in August
1888) is the one now at the
Courtauld Institute Galleries,
London; the two differ in their
colours and the positions of the
signature. Van Gogh was very
enthusiastic about both versions of
this picture, writing to Theo, 'This
fourth one is a bunch of fourteen
flowers against a yellow
background, like a still-life of
lemons and quinces that I did some
time ago. . . . One of the decorations
of sunflowers on a royal blue
background has a "halo" – that is to
say, each object is surrounded by a
glow of the complementary colour of
[its] background. . . .'

A Mind Divided

Towards the end of February 1889 a petition was sent to the mayor of Arles requesting that Van Gogh be interned in the hospital, as his behaviour was grievously disturbing the citizens. He was taken there on 27 February and was almost immediately befriended by a Protestant clergyman named Salles, who got in touch with Theo and persuaded him that all his brother needed was peace, less drinking, and regular meals, and that an ideal place would be the asylum of Saint-Paul-de-Mausole at Saint-Rémy, 25 km (15 miles) north-east of Arles.

Van Gogh agreed to become a voluntary patient at the asylum, which he entered on 8 May. It was, in fact, quite a pleasant place, close to the basilica of Saint-Rémy and some Roman ruins. He had his own room, with grey-green wallpaper, sea-green curtains, and shabby but comfortable furniture; through the iron-barred window he could see the Provençal countryside. As there were only a few patients there, he was given another room for use as his studio. This was to be his home for a year and a week.

For much of the time his mind was rational, his behaviour orderly. He was allowed to go out and paint in the countryside, accompanied by an attendant. He wrote frequently and lucidly to Theo and many other people, describing his life, talking about his pictures, and analysing his mental state. Artistically it was a period of great activity. During his stay there he produced about 150 paintings and a great number of drawings and watercolours. It seemed as though he was intent to use his art as a form of therapy, finding in the sinister shapes of the cypress trees symbols of his own disquiet, shaping the contours of the landscape and the configurations of the clouds into savage arabesques, with the paint laid on so thickly that he was always writing to Theo pleading with him to send more supplies.

Van Gogh had need of what release he could find from the demons who spasmodically beset him. His attacks of insanity, when they came, were appalling. He became prey to hallucinations, drinking lamp oil, turpentine – anything he could get hold of; he was violent and suicidal; his whole body would become convulsed. In the few lucid moments he had during these attacks, he would make small sketches, but, significantly, these were invariably scenes from the past – variations on the theme of *The potato eaters*, of the church at Nuenen, or of other Dutch scenes; they were never to do with Provence.

The precise nature of his mental disease is uncertain, but its possible causes were manifold. There was a family background of mental disturbance: one of his sisters spent most of her life in an asylum, and Theo was to suffer psychotic disturbances before his death in 1891. Van Gogh was also riven by guilt about his rejection by his father and the furious rows that had taken place between them. He never completely recovered from the venereal disease which had afflicted him in Antwerp. Finally there was his heavy consumption of absinthe, the cheapest of all spirits, and notorious for the damage it can do to the brain (it was later banned in France).

By the spring of 1890, two months after he had learnt that one of his paintings had been sold in Brussels for 400 francs, Van Gogh had had enough of Saint-Rémy. He decided to go to Paris. Theo was terrified, and suggested that he should come down to fetch him, or arrange for him to be accompanied. 'I'm not dangerous,' replied Vincent angrily, 'I've been a patient for a year or more; I've never done any harm to anybody. Is it just that I should be accompanied, like a wild beast? Anyway, I'm so upset at leaving in this way that I couldn't possibly go mad on the train.' He did not, and he arrived safely in Paris on 18 May. In the Saint-Rémy hospital register there appeared beside his name the observation: 'Cured'.

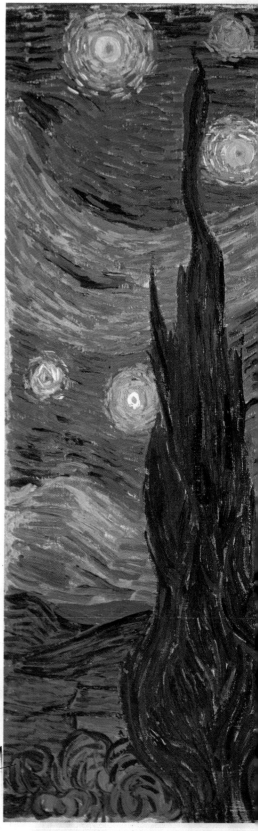

Starry night
June 1889
Oil on canvas
73 × 92 cm (28¾ × 36¼ in)
New York: Museum of Modern Art

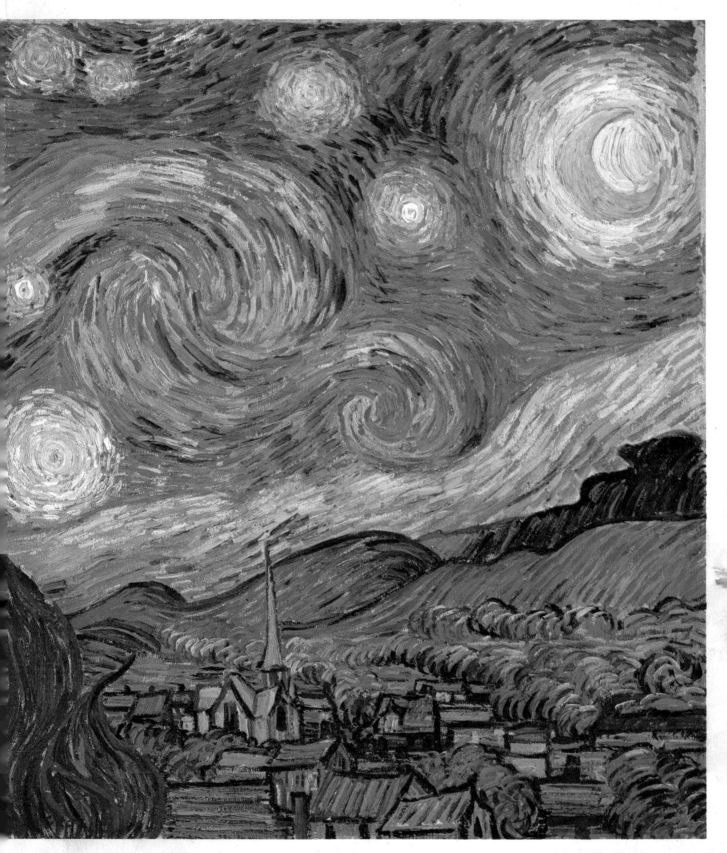

The flame-shaped cypress trees, the stars glowing like great catherine-wheels in the tumultuous radiance of the night-sky, the fierce golden-orange glow of the moon, and the quiet row of houses dominated by the village church combine to make this one of Van Gogh's most emotionally powerful paintings. It is a statement springing from the depths of his being, and his search for a personal style. When he saw the painting, Theo complained that Van Gogh's search for style had taken him away from a real feeling for things. Vincent saw it differently, asserting that the painting reflected a firmer, more masculine technique.

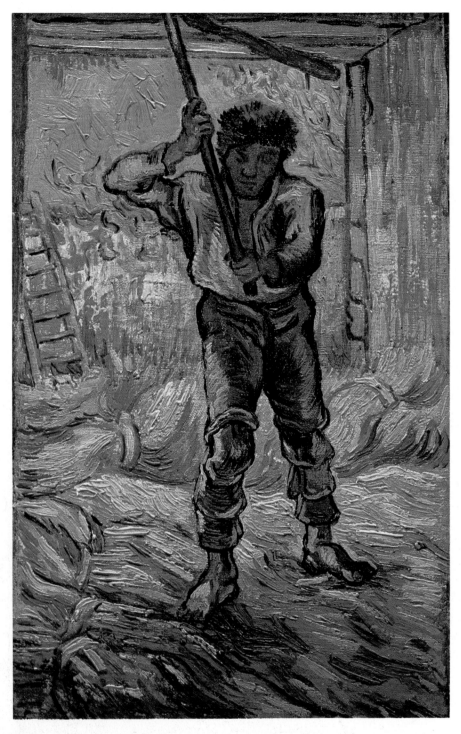

The thresher (after Millet)
September 1889
Oil on canvas
44 × 27 cm (17¼ × 10¾ in)
Amsterdam: Rijksmuseum (Vincent van Gogh Foundation)

The respect and admiration which Van Gogh had felt for Millet never deserted him. Just as his early works were influenced by that painter of French country life, so at the end of his life he still turned to him for inspiration. This and other paintings of a similar nature were based on prints of Millet's 10 engravings, *Travaux des champs* (Work of the fields). 'I can assure you that making copies interests me enormously', Van Gogh wrote, and he saw work of this sort as not only good for him as an artist but as a means of alleviating the pressure of his mental illness.

Wheatfield with cypresses
July 1889
Oil on canvas
72.5 × 91.5 cm (28½ × 36 in)
London: National Gallery

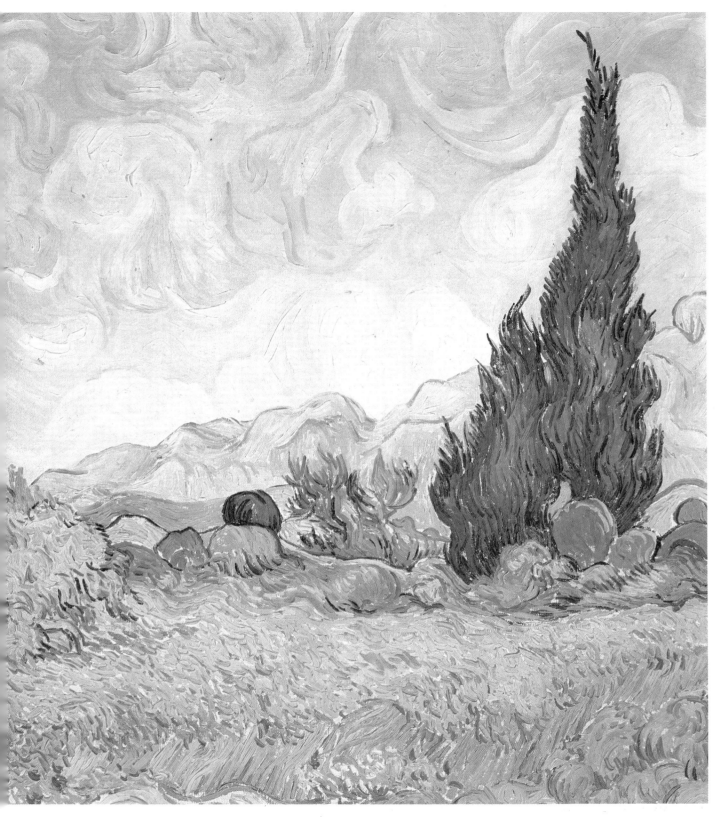

This view of a wheatfield outside the village of Eygalières, east of Saint-Rémy, seems to have appealed deeply to Van Gogh: there are four versions of this particular view, one of them a drawing. He sent two versions to Theo on 28 September, and this one was probably painted just before the onset of his fourth nervous collapse on 8 July. Although the tangle of clouds and their fierce undulations – a feature of all three paintings – seem indicative of stress, the rest of the landscape is powerfully lyrical rather than hysterical in feeling. The composition is unusual in that the dark shape of the large cypress tree is much further to the right of the canvas than might have been expected in a more conventional arrangement.

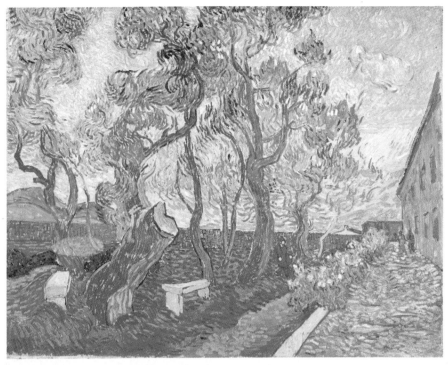

The garden of Saint-Paul's hospital
October 1889
Oil on canvas
73.5 × 92 cm (29 × 36¼ in)
Essen: Museum Folkwang

Noon: rest from work
January 1890
Oil on canvas
73 × 91 cm (28¼ × 35¾ in)
Paris: Louvre

Van Gogh moved into the asylum of
Saint-Paul-de-Mausole in Saint-Rémy
on 3 May 1889, and although he had
an extended period of madness from
early July to mid-August, he spent
much of the rest of his year there
painting happily enough. His style,
however, had altered a good deal,
with much more emphasis on
sinuous lines and more startling
colours. His paint was laid on so
heavily that one of the nuns who
worked in the asylum compared it to
'swallow droppings'. He wrote about
this work to Theo: 'Here is a
description of the canvas which is in
front of me at the moment . . . on the
right a grey terrace and a side wall
of the house. Some deflowered rose
bushes, on the left a stretch of the
park . . . the soil scorched by the sun,
covered with fallen pine needles.'

In 1858 Adrien Lavieille produced
engravings of Millet's series known
as 'The Four Hours of the Day'
(morning, noon, evening, night). Van
Gogh had acquired a set of these
engravings and early in 1890 he
painted versions of all four. *Noon:
rest from work* was the first to be
completed. In this, as in the others,
Van Gogh kept remarkably close to
the design of Millet's original. It is,
of course, in the highly personal
brush-work, in the sombre gold of
the hay, and in the sense of
pervasive mid-day drowsiness, that
he reveals his own personality.
Working from a black-and-white
reproduction he has achieved what
Millet conceived to be his own most
important aim in art: 'to make the
trivial into the sublime'.

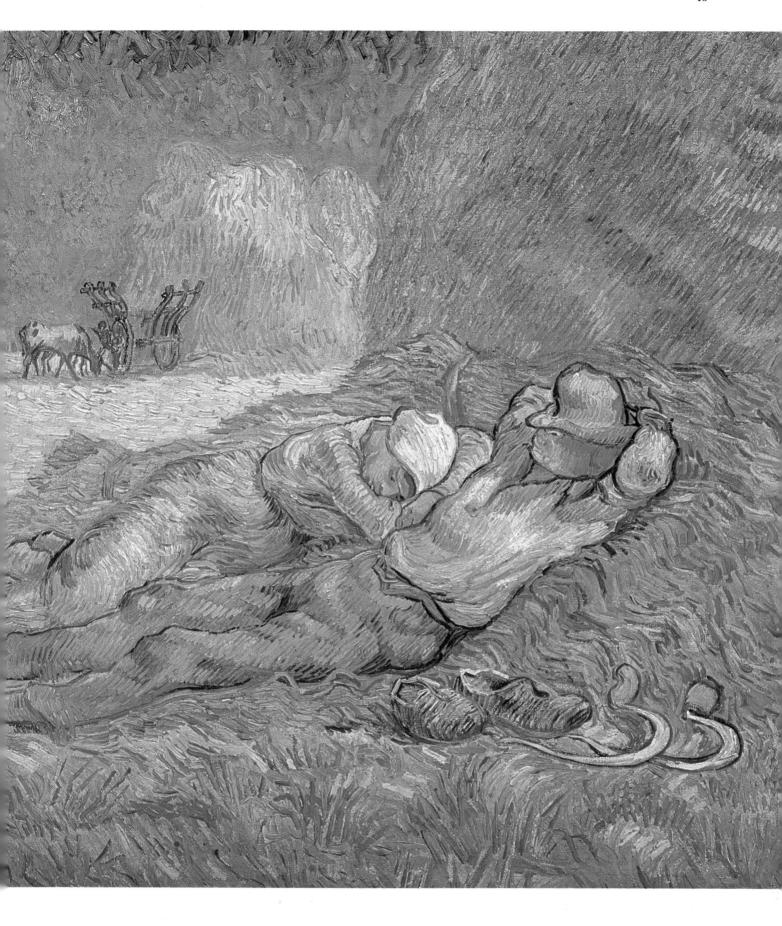

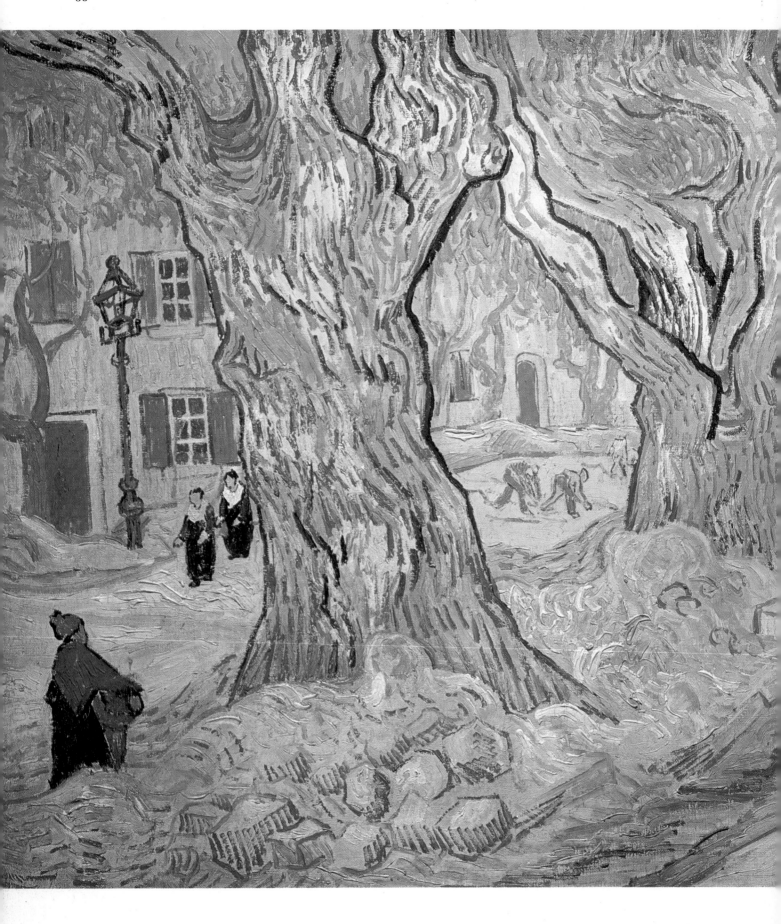

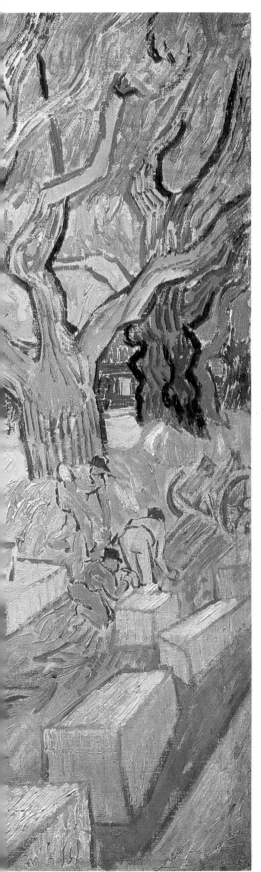

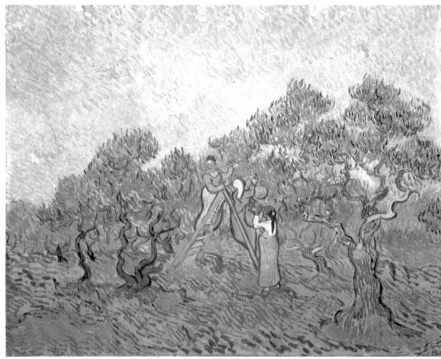

Road-menders at Saint-Rémy
December 1889
Oil on canvas
73.5 × 92.5 cm (29 × 36½ in)
Washington: National Gallery of Art
(Phillips Collection)

The curious thing about this
painting is that, despite the title, the
road-menders are the least noticeable
feature of the entire composition.
The picture is dominated by the
massive, twisted forms of the plane
trees and the heaps of sand and
stones. The location of the picture is
the Boulevard Mirabeau in Saint-
Rémy, which looks much the same
today. Van Gogh made two almost
identical versions of this painting:
this original one, which he kept, and
another which he sent to Theo.

Olive picking
December 1889
Oil on canvas
73 × 92 cm (28¾ × 36¼ in)
Washington: National Gallery of Art
(Chester Dale Collection)

Van Gogh was fascinated by the
recurrent cycle of farm activities in
Provence, and painted several
pictures of that most characteristic
of Provençal labours, olive picking.
Probably because the subject was so
remote from those familiar in
Holland, he painted the picture
specially for his mother, to whom he
sent one of a set of three almost
identical in subject and treatment.
He wrote to Theo: 'I am working on
a picture at this moment, women
gathering olives. These are the
colours: the ground is violet and,
farther off, yellow ochre; the olive
trees, with bronze trunks, have
greyish green foliage; the sky is
pink, and the three small figures
pink too. The whole is a very
discreet colour scheme.' Van Gogh
was in fact describing this canvas,
which was painted at the asylum
and was based on a version painted
on the spot the previous month.

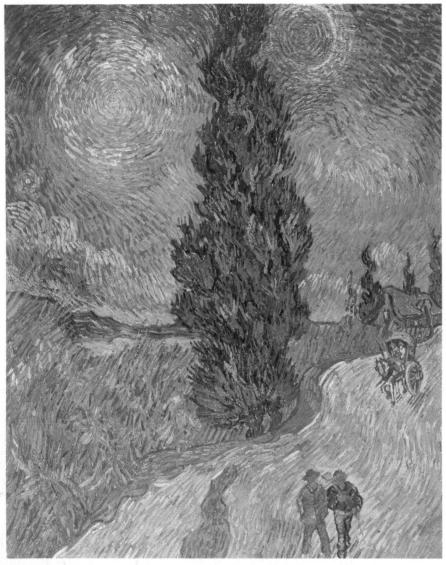

Road with cypress and star
May 1890
Oil on canvas
92 × 73 cm (36¼ × 28¾ in)
Otterlo: Rijksmuseum (Kröller-Müller Collection)

Van Gogh's preoccupation with stars surrounded by nimbuses of cloud remained constant to the end. This striking composition he described to Theo as '. . . a night sky with a moon without radiance . . . a star with an exaggerated brilliance, if you like, a soft brilliance of rose and green in the ultramarine sky, across which hurry some clouds. Below, a road bordered with tall yellow canes, behind these the blue Basses Alpes, an old inn with yellow-lighted windows, and a very tall cypress, very upright, very sombre. On the road a yellow cart with a white horse, and two late wayfarers. Very romantic, if you like, but *Provence* also I think.'

Poppy field at Saint-Rémy
April 1890
Oil on canvas
71 × 91 cm (28 × 35¾ in)
Bremen: Kunsthalle

This panoramic view of the Provençal landscape reveals the extent to which Van Gogh had acquired painterly skills of a remarkable order by the last months of his life. The composition is complex, with a large number of fields stretching away into the distance, each clearly defined in terms of the crop it is bearing. The poppies of the title play a minor part in the picture, although they flicker unexpectedly in different parts of the canvas. The colours in general are less violent and the brushwork is less feverish and more delicate than in most of the other paintings he did about this time, of which the exuberant *Road with cypress and star* is typical.

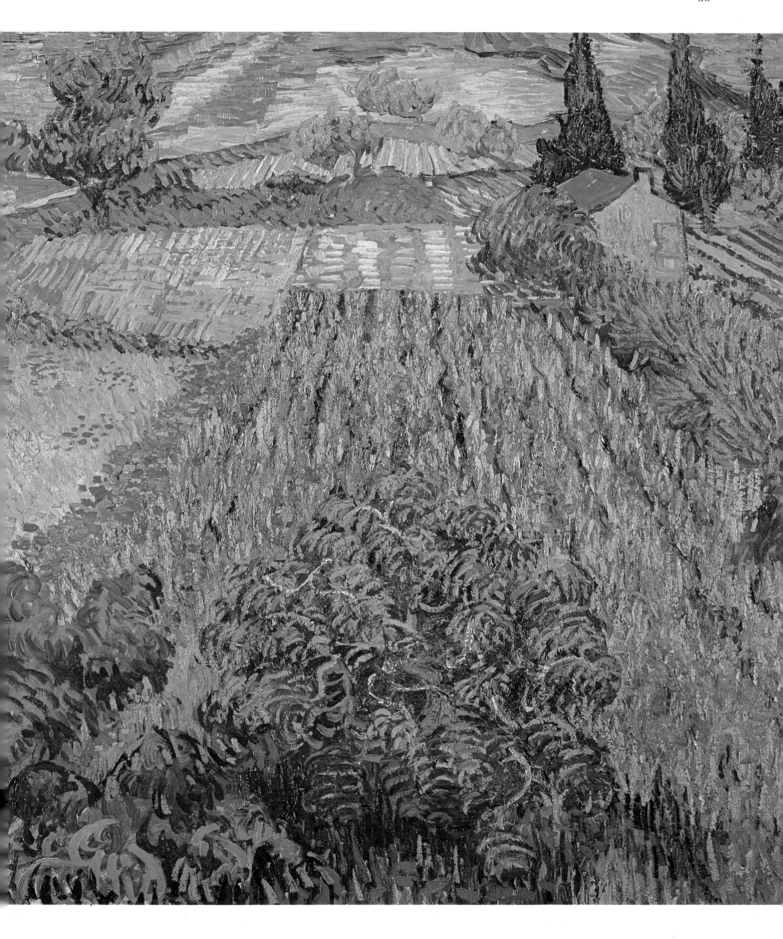

The End and the Beginning

Van Gogh arrived in Paris on 18 May 1890, and spent three days with Theo, meeting for the first time his sister-in-law Johanna and his recently born nephew, named after him. He then caught the train for Auvers-sur-Oise, a small town 27 km (17 miles) north-west of Paris, where – on the advice of Camille Pissarro – he was to live under the supervision of a noted if slightly eccentric psychiatrist, Dr Paul-Ferdinand Gachet, who was also an art collector and the friend of many contemporary painters. He rented an attic room at the cheapest place he could find, the Café Ravoux, in the main square of the town, facing the town hall; but he took most of his meals with the Gachets, whose charming house, with its walled, terraced garden and its cypress trees, entranced him. Van Gogh got on well with the doctor, went for long country walks, and painted with his usual fervour, completing 70 oils and 30 watercolours in 70 days.

Theo visited him, with his wife and child, and they had a happy picnic together. But Theo himself was going through a bad time; he had quarrelled with his firm, the responsibilities of a family were weighing heavily on him, the baby was frequently ill. Vincent reacted to his brother's problems, writing to him: 'Back here, I still feel very sad and continue to feel the storm which threatens you weighing on me, too. You see, I generally try to be fairly cheerful, but my life is threatened at the very root, and my steps are wavering.' To make matters worse Vincent started to turn against Gachet; he was especially incensed by the way in which the doctor kept paintings he had bought from Manet, Pissarro, and Cézanne unframed, unhung, propped up against the walls. On one occasion he pulled out a revolver, pointed it at the doctor, and then rushed horror-struck away. Now he was frightened of himself; he was alone, abandoned.

On the evening of 27 July he left his attic room, went to a remote field outside Auvers, and shot himself in the chest. The bullet passed near the heart, but missed it. Clutching his coat to himself to hide the wound, he struggled back to Auvers, and managed to make his way to his room. Shortly after, his landlady Madame Ravoux heard him groaning and called a doctor. By candlelight the doctor examined the wound and found that the bullet was lodged in an inaccessible spot near the spine. 'Missed again,' Van Gogh moaned to Theo, who came post-haste from Paris; but two days later he died in his brother's arms. United in life, the two were to be united in death, for Theo died six months later and was buried beside Vincent in the little graveyard at Auvers.

Before he died Theo had been trying to arrange an exhibition of his brother's works, and the task was carried on enthusiastically by his widow Johanna. At the Salon des Indépendants – the academy of the avant-garde in Paris – in March 1891 a retrospective exhibition of 10 paintings by Van Gogh attracted an enthusiastic review from a well-known art critic, Octave Mirbeau. The first major one-man show of his works (some 45 of them) was held at the Hague in May 1892, and in 1910 the German critic and art historian Julius Meier-Graefe published an important study of his works – the first of a total of 779 books to be devoted to Van Gogh over the next 70 years. It was in that year, too, that his works were first shown in London at the Grafton Galleries – to be greeted with howls of execration by most of the established critics. Since then there have been some three hundred important exhibitions of his works, and today no national gallery in the world would consider its modern collection to be complete without one of his paintings.

Thatched roofs at Cordeville
June 1890
Oil on canvas
72 × 91 cm (28¼ × 35¾ in)
Paris: Louvre

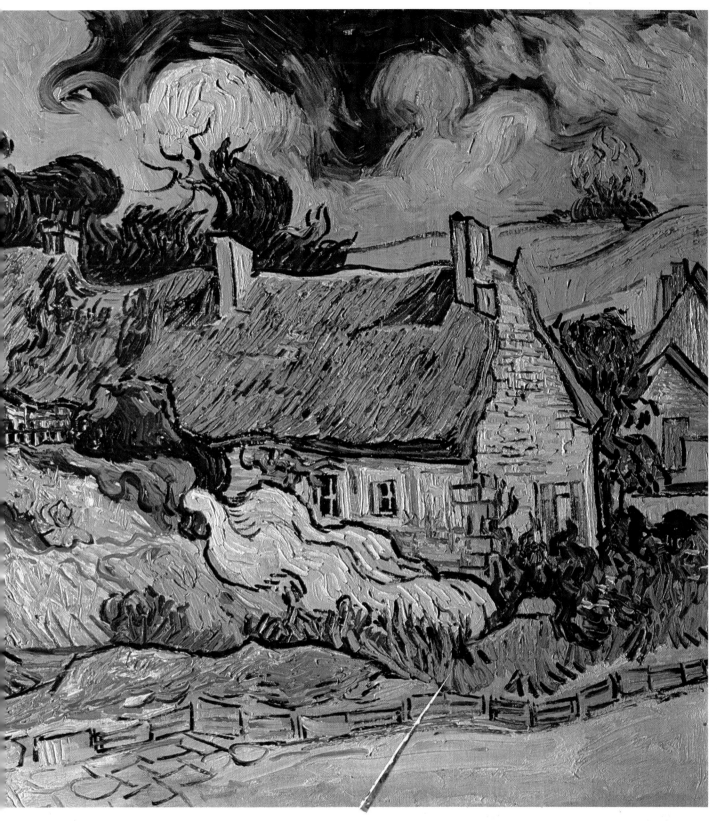

Having journeyed north from Provence, Van Gogh spent much of the last 10 weeks of his life wandering with paints and easel about the Val d'Oise near Auvers and recording scenes in the small villages. This painting – for long thought to be of cottages at Montcel, but ultimately located correctly by Dr Gachet's son Paul – is typical of several in which ostensibly 'picturesque' rural subjects are transformed into something altogether more disturbing in Van Gogh's hands: here quivering, undulating lines, violent colours, tormented skies, and strangely distorted roads and paths that seem to deny the rules of perspective – all create an impression not of rural peace but of vibrant anguish.

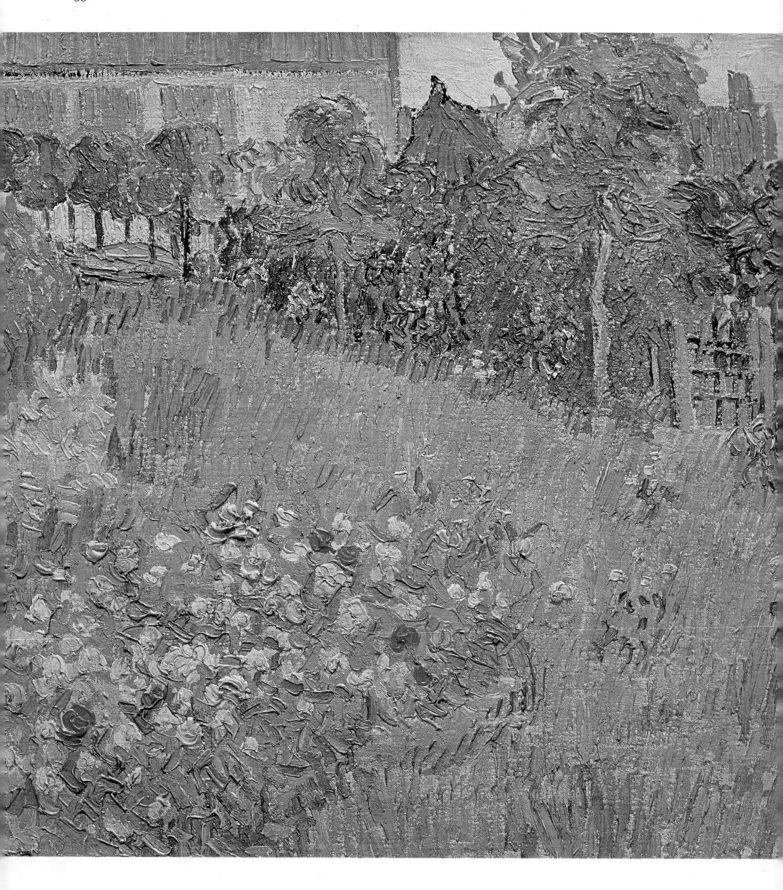

Corner of Daubigny's garden
June 1890
Oil on canvas
51 × 51 cm (20 × 20 in)
Amsterdam: Rijksmuseum (Vincent
van Gogh Foundation)

Van Gogh had for long admired the
works of Charles-François Daubigny,
a painter and graphic artist who
(like Millet) had been a member of
the Barbizon School, a movement
formed to advance the art of
landscape painting. Theo dealt
extensively in Daubigny's works,
and while working in Goupil's
gallery in Paris Van Gogh had had
opportunities to study their calm,
reflective approach to nature. This
liking for Daubigny persisted, and
was one of the points of
disagreement with Gauguin, who
disliked such placid, unemotional
paintings. Daubigny had owned a
farm and a house in Auvers, and
Van Gogh had been interested in
them ever since his arrival at Dr
Gachet's clinic, being especially
taken by the view of the church
seen from the garden. (Gachet
himself had known Daubigny well
and had met the painters Daumier
and Corot at his house.) This small
painting seems remarkably free of
psychological stress; it was, in fact,
a preliminary sketch for two larger
and much more restless versions
painted a week or two later.

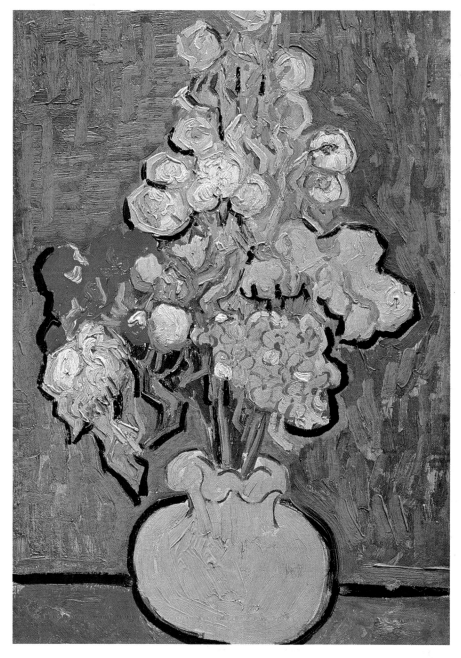

Vase with rose mallows
June 1890
Oil on canvas
42 × 29 cm (16¼ × 11½ in)
Amsterdam: Rijksmuseum (Vincent
van Gogh Foundation)

Soon after his arrival in Auvers, Van
Gogh returned briefly to what had
been one of his favourite subjects
during his Paris and Arles periods –
vases of flowers. Most of these final
still-lifes seem to have been painted
in Dr Gachet's house, and some of
the actual vases have been
identified. Van Gogh's treatment is
very different from that used in the
earlier flower vases (see page 43).
The shapes of the rose-mallows in
this work are more intricate, more
unexpected; the paint is thicker and
the composition hovers on the verge
of being top-heavy, but the colours
have a burning vitality.

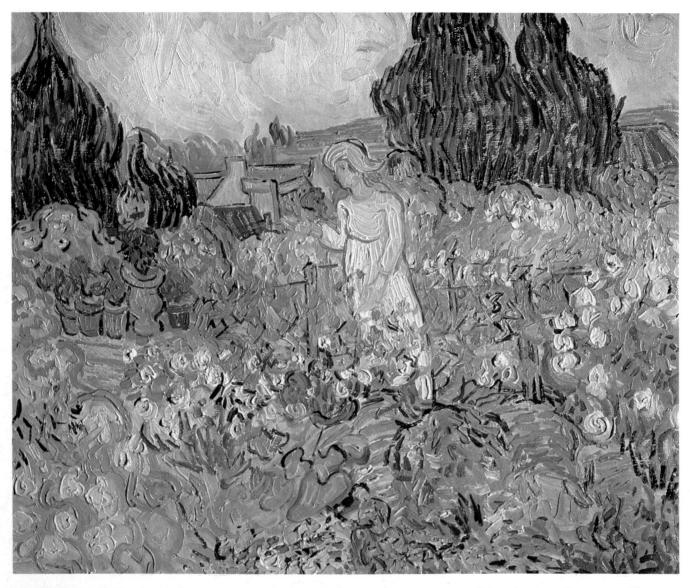

Marguerite Gachet in the garden
1 June 1890
Oil on canvas
46 × 55 cm (18 × 21¾ in)
Paris: Louvre

'Every week I shall stay at Gachet's
house one or two days in order to
work in his garden, where I have
already painted two studies, one
with white roses, some vines, and a
figure,' Van Gogh wrote reassuringly
to his brother. It is significant that
in thus describing this work, he
mentions the figure (Dr Gachet's
daughter) last. It seems to blend
almost imperceptibly into the heavily
painted wealth of flowers in the
garden. The trees in the background
add a dramatic note to the
splendour of colour in the foreground.

Portrait of Dr Gachet
Early June 1890
Oil on canvas
68 × 57 cm (26¾ × 22¼ in)
Paris: Louvre

Paul-Ferdinand Gachet, who had
been recommended to Theo by the
painter Camille Pissarro as a
suitable person to look after
Vincent, was in many ways a
remarkably eccentric character;
indeed, Van Gogh himself declared
that it was only 'his experience as a
doctor which keeps him balanced by
counteracting the nervous disorder
from which he seems to be suffering
at least as seriously as I am'. An
ardent republican, an atheist, a
believer in free love, cremation, and
homoeopathic medicine, Gachet had
moved in literary and artistic circles
since his youth in Paris, and in
addition to being an amateur etcher
and draughtsman he was an ardent
collector of Impressionist paintings

and was on friendly terms with most
of the major figures in the
movement. Doctor and patient made
a strong impression on each other,
which soon turned into friendship,
and two weeks after first meeting
him Van Gogh reported to Theo: 'I
am working on his portrait, his head
with a white cap, very blond hair,
very bright; his hand also light in
colour, with a blue coat and a cobalt
blue background. . . . M. Gachet is
absolutely *crazy* about this portrait'.
He had found not only a doctor and
a friend, but someone who admired
his work. (This is one of two
versions of the portrait; the pose is
almost identical in each.)

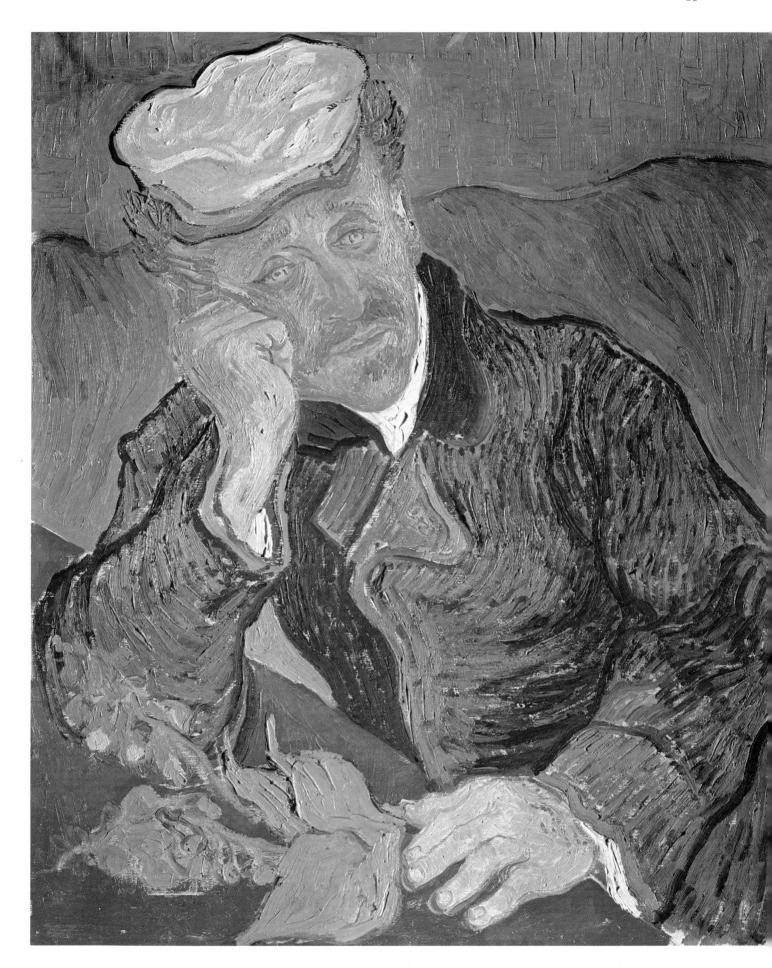

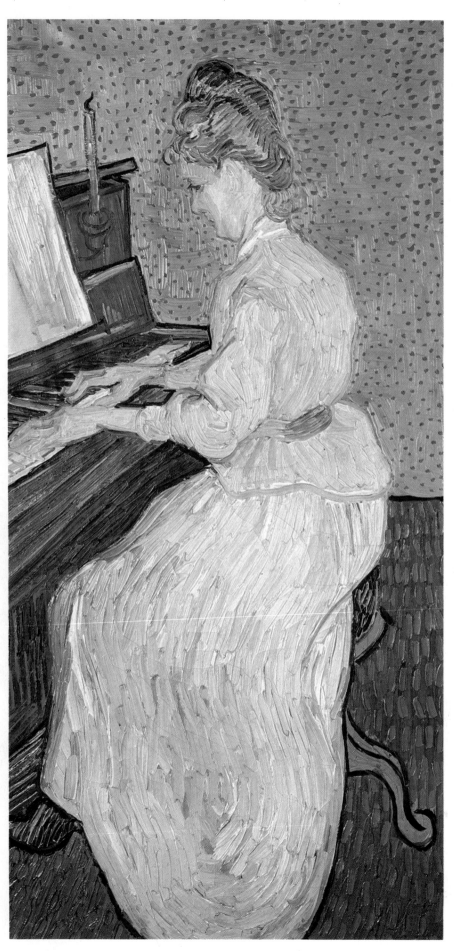

Marguerite Gachet at the piano
Late June 1890
Oil on canvas
102 × 50 cm (40¼ × 19¾ in)
Basel: Öffentliche Kunstsammlung

Van Gogh, with that degree of shrewdness which was as much a part of his make-up as his idealism, thought that in his new-found friend Gachet he had discovered a source of commissions for portraits, as the doctor had a wide range of friends and patients. It was no doubt this consideration as well as sentiments of friendship which impelled him to paint this portrait of Marguerite Gachet, the 19-year-old daughter of the house. Although there is a certain ungainliness in the hands, the face seems a convincing likeness. The paint is laid on very thick, but the mannered arabesques of some of his works of this period are missing. He wrote to Theo: 'It is a figure that I painted with enjoyment, but it is difficult. [Gachet] has promised to make her pose for me another time at the small organ. . . . I have noticed that this canvas goes very well with another horizontal one of corn, the one canvas thus being perpendicular and in rose, the other pale green and greenish yellow, the complementary of pink . . . but we are still far from the time when people will understand the curious relations which exist between one fragment of nature and another, which still explain and set off each other.'